Women of the Catskills

Women of the Catskills

STORIES OF STRUGGLE, SACRIFICE & HOPE

RICHARD HEPPNER

Charleston London

THE
History
PRESS

Published by The History Press
Charleston, SC 29403
www.historypress.net

Cover images courtesy of the collection of Frederick Allen, Vedder Research Library, Historical Society of Woodstock, Library of Congress and Richard Heppner.

First published 2011
Manufactured in the United States
ISBN 978.1.60949.014.0

Library of Congress Cataloging-in-Publication Data

Heppner, Richard R.
Women of the Catskills : stories of struggle, sacrifice, and hope / Richard Heppner.
p. cm.
Includes bibliographical references.
ISBN 978-1-60949-014-0
1. Women pioneers--New York (State)--Catskill Mountains--Biography. 2. Women--New York (State)--Catskill Mountains--Biography. 3. Catskill Mountains (N.Y.)--Biography. 4. Women--New York (State)--Catskill Mountains--History--Anecdotes. 5. Catskill Mountains (N.Y.)--History--Anecdotes. 6. Catskill Mountains (N.Y.)--Social life and customs--Anecdotes. 7. Catskill Mountains (N.Y.)--History, Local--Anecdotes. I. Title.
F127.C3H47 2011
974.7'38--dc22
2011009968

This book is dedicated to the women of the Catskills who have shaped and guided my life and to those who work each day to preserve the history that is in our own backyard—or just up the road a little.

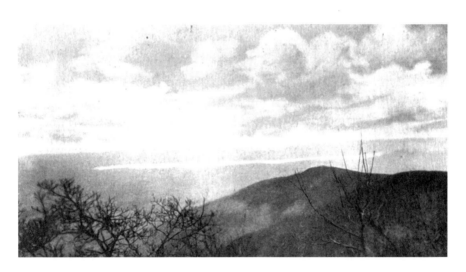

Early view from Meads Mountain House, Woodstock, New York, looking westward across the Catskills. *Photo Courtesy the Historical Society of Woodstock.*

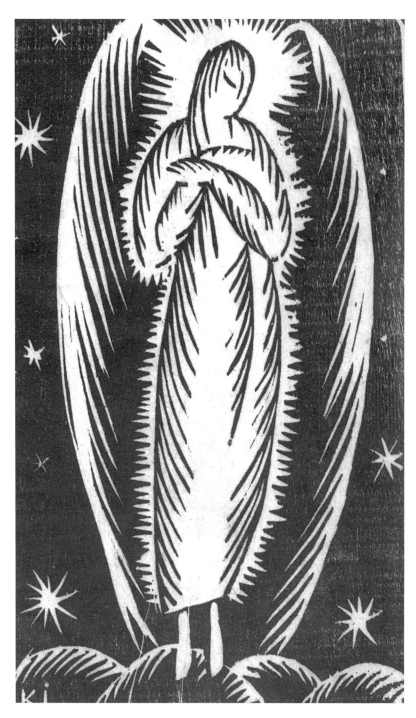

Angel, a 1920s woodcut of an angel overlooking the mountains by Ilonka Karasz.
Courtesy Historical Society of Woodstock.

"The Catskills"

Dear mountains, that stand in the sunlight,
In mantles of purple enrolled,
The dews of the dawn on your faces,
Your foreheads encircled with gold;
You're no strangers to me, so "Good-morning,"
For you live simply over the way;
So long have I known you as neighbors
That I hail you as comrades to-day.

Earth calls, but you heed not the summons,
The Hudson sings low at your feet,
The pines fold you close in their pleadings,
Each kiss of the violets is sweet.
But fearless and stanch ye make answer:
"We must break from these trammels of clay;
Our Maker commands, 'Come up higher,'
So, hearing his voice, we obey."

I think, as I look on your faces,
As I mark the proud strength of each form,
How grandly, through ages, defiant,
Ye have battled with lightning and storm;
And I honor ye, heros undaunted,
As ye stand in the glow of the west,
That, through sunshine and shadow untiring,
Ye have steadily climbed to the best.

Dear mountains, ye teach me a lesson
That my soul reaches out to obey;
Let me learn from your lives to look upward,
Let me cast off the stain of the clay.
Earth calls; but, oh, joy! far above me
Bend the heavens enraptured with fire;
Let me climb to their heights, looking skyward,
Since to grow simply means to aspire.

—Harriet Mabel Spaulding, 1887

Contents

Acknowledgements

This work began as a small idea that was encouraged and supported along the way by a number of friends, colleagues and those interested in local history. As the idea grew, so too did the number of individuals and institutions that lent their support. To that end, I would like to thank and acknowledge the following for their assistance and the work they do preserving our historical records:

The Historical Society of Woodstock
Vedder Research Library
The Delaware County Historical Association
Princeton University Library
Orange County Community College Library
Kingston Library
James M. Milne Library at SUNY-Oneonta
Woodstock Library
The Town of Woodstock
Deborah Heppner
Eliza Heppner
Barry Samuels
Jean White

ACKNOWLEDGEMENTS

JoAnn Margolis
Tobe and Meg Carey
Tim Mallery and the *Catskill Archive*
Whitney Tarella
Frederick Allen
Addison Jones

On Arrival: An Introduction

As a child, I heard their names frequently: Grandma Ostrander, Aunt Effie and Aunt Anna, to name a few—names that connected me across time and distance and to relatives that went before. Their stories were often revealed to me during wild Sunday drives through Catskill Mountain towns like Chichester, Roxbury and Andes. They were wild because of my grandfather's driving skills. One hand on the wheel, the other perpetually pointing at a small farm here or a tiny white clapboard house there, we would take sharp mountain curves at breakneck speeds, braking only when we pulled up behind another car whose driver, glowering in the rearview mirror, seemed to possess an understanding of the word "limit," as in speed limit. Sitting in the back seat, usually between my mother and her sister, I would be tossed from side to side as they, without any real conviction or hope for success, urged their father to slow down.

I would survive those Sunday drives. Also surviving were the memories of those relatives who crafted what lives they could from the small plots of land that was theirs, taking what they could from the nearby streams and surrounding forests to sustain themselves. It wasn't until much later that it finally dawned on me that the names I often heard on those Sunday drives were that of women—women, I would find out later, who had

long outlived their husbands or had never married; women who, through sheer determination, had forged a life bearing witness to their strength, ingenuity and creativity. No one ever told them it was a hard life, though their faces and their hands echoed the content of their days. It was the only life they knew—the one they were given—and they lived it with a dignity specific to the context of their physical surroundings.

Years later, as I began my pursuit of local history, I would again remember the women of which my grandfather spoke. More and more, as I read, wrote, conducted research and pursued the history of Woodstock, New York, I became aware that the history I loved so much openly omitted the vital role women had in writing not only Woodstock's story, but that of the Catskills as well. Though occasionally acknowledged, their experience has been basically ignored. Like most of history, I will grant the reader the point that our collective past is one in which power, wealth, benefit of law and the historian's pen has been held in the hands of men. That said, the notion or the argument that women were primarily absent in forming and shaping the direction of our local history is a false one. They are there. Though their stories are often found in the footnotes of larger histories, in family albums, in obscure essays or stories produced by local historical societies or in a review of locally preserved newspapers (usually, well beyond the front page), they are indeed there.

Most who have encountered New York State's Catskill Mountains have done so through the idealistic works offered by Washington Irving and Thomas Cole. Embracing the romantic era of the nineteenth century, where belief in nature's truth and the spirit of the individual held firm, many first met the Catskills through tales such as Irving's *Rip Van Winkle*, while delighting in the pastoral glow of its waterfalls, mountain streams and ragged peaks, as depicted in the paintings of Cole and the other Hudson River artists. In many respects, much as we bemoan the creation of instant perceptions by our electronic media today, so too were idealistic constructs created within the romantic era that would shape the worldview of the Catskills for years to come.

There is, however, a reality to the history of the Catskills that runs counter to the romanticism that has shaped its popular history. As noted historian Alf Evers wrote in his seminal text, *The Catskills: From Wilderness to Woodstock,*

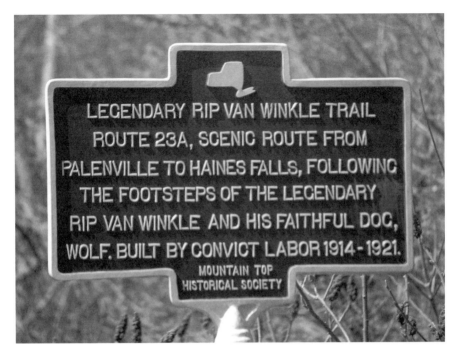

A historic marker, erected by the Mountain Top Historical Society, notes the area where Washington Irving's Rip Van Winkle took his famous "nap." *Photo by the author.*

Among the mountains, two powerful sides of life have operated side by side and, by a thousand strokes, giving the region it's shape. One was the greed for land and wealth and the power over others, which both symbolize; the other was the free play of the imagination in the arts and in the exploration of nature. Sometimes the two forces worked together, more often they were locked in battle. The story of their relationship is, at the same time, the story of three centuries of the Catskills.

But even the history cited by Evers fails to provide a complete telling. For in the reality of its story, the history of the Catskills has seldom been told or viewed through the words, voices or deeds of the women who also struggled to forge a life within the notches and the hollows of these mountains—women who were the "others" when it came to the power exercised by a male-dominated culture; women who, through sheer will and character, altered the history of the Catskills in ways both large and

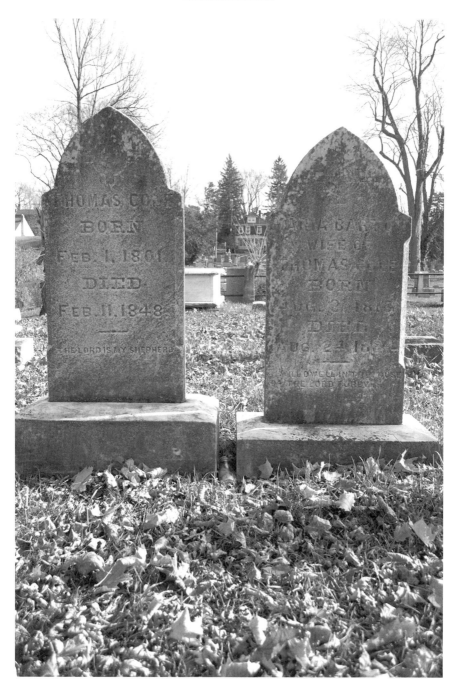

Graves of Thomas Cole, founder of the Hudson River School of painting, and his wife, Maria Bartow Cole, at the Thomson Street cemetery, located in Catskill, New York. The Thomas Cole National Historic Site is also in Catskill. *Photo by the author.*

small. From the days when Native Americans once roamed these valleys, to the first white settlers, from the time of overbearing landlords and the burdens of life leases, through the struggle for political independence and equality, the women of the Catskills have been an integral, if unheralded, part of Catskill Mountain history.

The women that you will meet in the pages that follow are not individuals who have become household names. In most cases, their inclusion in this text follows no orderly, well-honed selection process. They are simply, but importantly, women whose stories offer a glimpse into the living done by women whose life circumstances placed them within the heart of New York's Catskill Mountains. In most instances, their stories do not speak of achieving great fame or engaging in heroic acts. Rather, it is how they chose to live their day-to-day lives and what they offered to others during moments of self-realization that is important. While it would be easy to praise them for the sacrifices they offered or to sympathize with the setbacks or tragedies they suffered, the lives examined here would never ask or expect such offerings. For most, they lived not for a cause greater than themselves but to survive.

New York's Catskill Mountains rise dramatically along the western side of the Hudson River. Long before white settlers arrived, Native Americans traversed its slopes to take game from its dense forests and fish from its streams. In 1609, the mountains first found written reference in the journal of crewmember Robert Juet, as Henry Hudson and the men of the Halfmoon became the first European eyes to behold the Catskills. Writing on September 15, Juet noted, "At night we came to other Mountains which lie to the Rivers side." Looking to the west, Juet, the crew and Hudson himself could not have failed but be drawn to the silhouette of Overlook Mountain rising above where the town of Woodstock lies today. For, as historian Alf Evers once described, "The mountain jutted out from the rest of the Catskills [and] seemed to assert its presence."

In 1708, under the reign of Queen Anne, the Hardenbergh Patent, granted to Johannis Hardenbergh, outlined a vast track of land—over two million acres, including portions of what is now Greene, Delaware, Ulster, Orange and Sullivan Counties—and set the stage for the eventual

development of the Catskills. Traders and early settlers followed. As the land that once separated tribes of Native Americans transitioned into America's western frontier—now separating whites and Indians—wealthy landlords such as Robert Livingston, eyeing the dense forests he viewed from his home across the Hudson, began to secure large tracts of land within the patent to bring a version of colonial economic development to the Catskills in the form of cutting and milling timber and tanning. Later, as urban expansion along the eastern seaboard increased the demand for bluestone, the mountains would come under further assault, as quarrying fed the rural economic engine. Ultimately, the era of the wealthy overseer would collapse—as would an unfair system of life leases—under pressures brought by tenants during the Down Rent War.

In the mid-1800s, understanding that there was profit to be made not so much in what they could take from the land but in what others saw in the land, entrepreneurs ushered in the era of the great mountain houses. From the Catskill Mountain House in the east to the Grand Hotel in the west, dayliners that now traveled the Hudson and locomotives that cut their way through the landscape brought visitors seeking escape from the

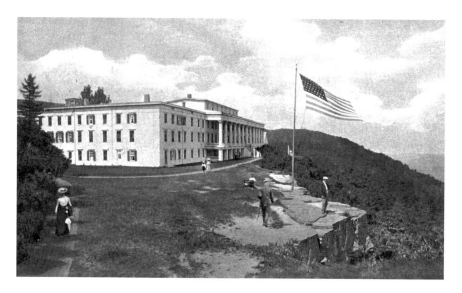

The Catskill Mountain House. Constructed in 1823 and opened in 1824, the Catskill Mountain House sat on an escarpment 1,630 feet above Palenville, New York. In its day, many considered it the preeminent hotel in the Catskills. *Photo courtesy of the Historical Society of Woodstock.*

heat and unhealthy air of urban environments. Over time, anti-Semitism and ethnic discrimination by many of the mountain houses eventually led to a new era in the southern Catskills, as hotels and resorts opened to create what became known as the "Borscht Belt." With the creation of the Catskill Forest Preserve in 1895, large tracts of land would be put aside as "forever wild," to be enjoyed by visitors and resident alike. While tourism, as a result, would continue to serve as a prime economic force within the Catskills, the same beauty that would bring visitors to explore the mountain slopes also captured the imagination of artists. From Thomas Cole's first visit to the Catskills, from Onteora to the Byrdcliffe and Maverick art colonies, a flurry of artistic and creative expression by artists, writers and musicians remains—and continues to sustain—the cultural legacy of the "hills of the sky."

Today, as the Hudson River wanders beneath its slopes, the Catskills continue to "exert their presence," beckoning visitors and newcomers alike. From the quiet of a Catskill Mountain trout stream toward the west, to the site of the 1969 Woodstock Festival in the south, to the eastern village of Catskill nestled along the banks of the Hudson, this wide expanse of gentle mountains looks skyward, bending the clouds and storms that move across its many faces while summoning those below to move upward. As I drive the back roads through Schoharie and Delaware Counties, pass through the small towns of Greene into Ulster County and move southwest through cornfields and apple orchards toward Sullivan County, I still look for the small farms and white clapboard houses my grandfather once pointed out. In some respects, not much has changed. Living goes on. Work, struggle, laughter, belief and hope still gather within walls known as home, much as it has for over two centuries. And, inside many of those same structures or on the same small plots of land where relatives once raised families, tended to their physical and emotional needs and sought, simply, to find comfort in what the mountains would share, women continue their work, building and sustaining their lives and the lives of those around them.

Today, history is still being made behind the windows and doors I pass. It is found in the individual path that, ultimately, merges with the main road we all share. The women of the Catskills who have gone before—through their struggles, their tragedies and their triumphs—have offered

The Catskills, following winter's first snow. *Photo by the author.*

a well-worn trail to follow. Through hard work, dignity and their embrace of the individual and creative spirit that is the gift of the mountains, ours has become a history rich with example. It is a history that has been shown the road to follow by the women of the Catskills.

Richard Heppner
Woodstock, New York

Chapter I

A Simple Act

Ruth Croswell's Quiet Voice

Some days are just more important than others. For Ruth Pierce, this was such a day.

The morning of April 30, 1789, dawned clear but cool in New York City. By midday, however, spring warmth had overtaken the large crowd gathered outside Federal Hall. As the noon hour passed, anticipation built as Pierce and the thousands around her waited for the moment to arrive. Now twenty-four, she was but ten years old when the first shots were fired at Lexington and Concord. The wait would soon be over.

With his appearance on the balcony above them, those assembled let loose with the excitement of a people who, at long last, were witnessing the promise of democracy delivered. And, when the man who had kept that promise came forward and bowed to them, the thousands gathered in the street below and on the rooftops above understood that the moment had arrived.

Though surrounded by a cluster of dignitaries, including the new vice president, members of the House of Representatives and the Senate, foreign ministers and Chancellor Robert Livingston of New York who would administer the of oath of office to the new president (there was no Supreme Court yet), George Washington was not difficult to spot.

As the young woman looked up at the balcony from her place in the crowd, she would have clearly seen the towering figure clad in a suit of dark brown, with a dress sword at his side. No doubt, as did the rest of the crowd, she too would have sensed, as Washington concluded his bows and moved to take a seat, that the great man had been obviously overcome by the scene before him. Almost on cue, the cheering died, and those gathered about her went quiet. The moment had arrived, and Ruth Pierce was about to bear witness to the birth of a new government.

As the last words, "So help me God" left the new president's lips, and he bowed to kiss the Bible before him, Chancellor Livingston, waving his hands, shouted to the crowd before him, "Long live George Washington." With a final bow to his countrymen, Washington turned and reentered Federal Hall to deliver his inaugural speech to Congress. The bells of the city that had announced the arrival of the day earlier that morning began their celebration once again. America had begun.

More than seventy years later, bells would toll once more in a different place and for more somber reasons. As the funeral procession passed through the village of Catskill, New York, their somber tone mourned the death of Ruth Pierce Croswell. It was a remarkable funeral. It was an especially remarkable funeral for a woman. As the procession moved through the streets of the small town where she had spent most of her ninety-six years, a newcomer might have wondered, what dignitary was this? For, passing before were not only family members but also clergy of all denominations. The procession moved past shuttered businesses—businesses that had closed not only out of respect but also so their owners could join the mourning. And the bells continued; they continued to ring from every church in the village. They continued in honor of a woman whose simple life was well lived—a life that straddled two very different centuries.

Ruth Pierce Croswell was born in Litchfield, Connecticut, on February 22, 1765, the same year the British Parliament stoked the already smoldering embers of revolution by "presenting" the American colonists with the ill-fated Stamp Act. In addition to George Washington, she would live through the election of the fifteen presidents that followed. Her death would come six months following the first Battle of Bull Run.

Ruth Pierce was the daughter of Mary Paterson and John Pierce. Sister to six other children, her younger years knew the loss of her mother at an early age. After remarrying, her father died when she was sixteen. Of her siblings, her sister, Sarah, would go on to become the founder of one of the earliest academies for young women in the new nation, the Litchfield Female Academy. Her brother, Colonel John Pierce, who would take on primary support of the family following their father's death, served as paymaster general for colonial forces during the Revolution. Ironically, it would be through her brother, John, that Ruth Pierce Croswell would have her second encounter with George Washington.

John Pierce married the daughter of Dr. Samuel Bard. Bard, an eminent physician in colonial New York—he helped found the first medical school in the state—became Washington's private physician during the time the federal government was centered in New York City. As a result of the union between the Pierce and Bard family, Ruth Pierce was extended an invitation to join Washington and his family for tea. The timing of her visit, however, coincided with a period in the life of the new president that saw him fall seriously ill. Research has shown that the cause of the illness "varies" depending on which source one believes, as reports range from Washington suffering from quinsy, a carbuncle or anthrax poisoning. Whichever the case, there was no doubt as to the seriousness of the president's illness at the time of Pierce's visit.

As related in the text *Chronicles of a Pioneer School from 1792 to 1833, Being the History of Miss Sarah Pierce and her Litchfield School* by Emily Noyes Vanderpoel, Ruth Pierce was in Washington's home when Dr. Bard, having just examined the president, entered the room and recounted, to those gathered, Washington's words concerning his illness and his own ultimate fate. As quoted in Washington Irving's Life of George Washington, Volume 5, the president asked Bard, "his candid opinion of his case":

> *Do not flatter me with vain hopes, said he with placid firmness. I am not afraid to die, and therefore can bear the worst.*
>
> *The doctor expressed hope but owned that he had apprehensions.*
>
> *Whether tonight or twenty years hence, makes no difference, observed Washington. I know I am in the hands of a good Providence.*

While Washington's recovery would be slow—it would be six weeks before he could leave his home—it was not long after her remarkable visit that Ruth Pierce became Ruth Croswell and took up residence in Catskill. Her husband, Thomas Croswell, had arrived in Catskill as a young man and, along with his brother, Mackay, published the first newspaper in the area, the *Catskill Packet*. Croswell, however, had a stronger calling and left his brother after a short time to take up the practice of pharmacy and medicine. While also serving as postmaster for the village, a position he held till his death, Thomas Croswell may well have been one of the most beloved men in the Catskills. Writing in 1856, James Pinckney recalled in his *Reminiscences of Catskill, Local Sketches,*

> *My earliest recollections of Dr. Croswell are associated with the sugar plums and licorice sticks with which his capricious pockets were stored, and which, for all my youth ailments, were a sovereign panacea whose sweet flavor still seems to linger on my tongue. I remember his kind looks and cheerful laugh, and can recall the very words of the nursery songs which he essayed to sing, albeit the melody was not of the richest, nor the music precisely such as would be adapted to a modern concert-room, for the chiefest merits of the Doctor's warbling was that it came directly up from his benevolent heart.*

In a 1968 document examining the Croswell family titled "The Croswells of Catskill," Frazer Hilder offers a further glimpse at the personal side of Thomas Croswell, as presented in a letter he wrote his wife from New York City while undertaking preparations for their new life in Catskill:

> *N. York 31 May 1792*
> *My dearest girl,*
> *I left Catskill tuesday before last, & came to town after a tedious passage of five days—Since I have been here I have not one moment's peace,—have been plagued with one disappointment in succession to another—Tomorrow, or the next day, I shall leave here—& although I much wish for the happiness of being with you—dare not promise to be in Litchfield before three or four weeks.—I have not got business*

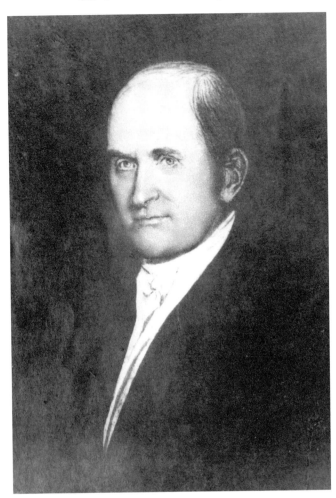

Thomas Croswell, husband of Ruth Croswell and beloved citizen and physician of Catskill, New York. *Photo courtesy of the Vedder Library Bronck Museum of Greene County Historical Society, Coxsackie, New York.*

into such a situation, as bids fair to allow me a little ease—& I look forward with eagerness to the time when we shall be <u>settled exactly right</u>, but let what happen that can—the happiness of Ruthy, will, more than any other thing interest the soul of.

Thomas

Theirs was a typical nineteenth-century marriage, though the word "typical" may give pause to those of us so engaged today. Within Hilder's "The Croswells of Catskill," we are treated to the following, albeit brief, description of their home life:

At home, although Dr. Croswell had great respect for his wife, he was fond of teasing her, all the more because she had little sense of humor. He disliked to have her visit or receive visitors. He went to bed early. She waited upon him in silence as a mother waits upon a child. She took his snuff-colored wig, gave him a nightcap and since his habit was to smoke for a while half-propped with pillows, she filled three or four clay pipes with tobacco and put them on a japanned tray within easy reach of his hand. This custom of retiring bedtimes kept his wife from going to the Wednesday-evening lecture and the Saturday-evening prayer meeting. Occasionally, while he smoked, he would, to her great pleasure, allow her to read to him a Psalm or a chapter from the Gospels.

Contrary to the above, as viewed from a twenty-first-century context, Ruth Croswell was no less respected than her husband. Yet, hers was the respect given the dutiful wife who, along with her husband, became pillars of the Catskill community. In many respects, when we consider the lives and roles of women in nineteenth-century America, it is possible that Ruth Croswell might have come right out of central casting. At her very core was her commitment to her Presbyterian faith. She was known to visit the poor and pray with those who were ill or approaching their last days on earth. She has been described as "quiet" but "quaint" in her "direct way of expressing her disapproval." Within her Christian community, she directly oversaw a female prayer meeting for over twenty-five years. She was not a complicated woman. There were no pretenses, no frills. She is perhaps best described in *The Chronicles of a Pioneer School*, where it is noted that her journal revealed "the heart of a humble, devoted, trustful, single-minded Child of God, very sensible of her imperfections, very penitent, watchful, and prayerful, resting on Christ alone for acceptance with God, and yearning to be holy."

As a good woman of faith and family, Ruth Croswell—"humble, devoted, trustful"—might have been forgiven by time and history had she simply kept her opinions to herself. Obviously, her friends of the day would have expected no less. And yet, in her simple and understanding ways—ways that no doubt stemmed from a faith that fostered her concern for social and moral reasoning—she was very much ahead of her time when, becoming alarmed over the developing trend of serving alcohol

in the form of cordials to local women gathered for afternoon "teas," she voiced her objection to the practice. It was, in its quiet eloquence, an objection offered long before the forces of Prohibition began to marshal enough strength to even consider amending the Constitution, and it led to a written pledge circulated throughout the village in which women agreed to abstain from serving alcohol at future functions. In many respects, it was a simple act. And yet, with that act, within that principled stand, Ruth Croswell became an early soldier in the undeclared war against alcohol. And while hers was an early skirmish in what would become the battle for temperance, it was not a popular stand, as, according to James Pinckney, her quiet objection would not escape criticism from some within the village she loved.

To understand the lack of popularity this initial step toward temperance occasioned, one need only look at how much Americans in general, and those in Greene County specifically, were drinking.

At about the time Ruth Croswell raised her seemingly small objection, the number of distilleries in the infant nation totaled "more than 14,000," according to a recent text titled, *Last Call* by Daniel Okrent. Only two short decades later, it was estimated that the American adult male was consuming seven gallons of pure alcohol a year, or approximately ninety bottles a year for every adult in the nation. In 1821, a time not too distant from Ruth Croswell's simple act, the alarming amounts of alcohol being consumed by Americans, as offered by Okrent, led George Ticknor, a professor of literature at Harvard, to confide in Thomas Jefferson, "We should hardly be better than a nation of sots."

While one of America's first organized efforts toward restricting the sale of alcohol, the Washington Movement, would not begin to take form until the 1840s, concern over the excessive use of alcohol and the move toward local temperance in Greene County, New York, where Ruth Croswell had already fired the first shot, had begun to receive serious attention by the 1830s. How much of a problem was alcohol in Catskill and Greene County? In an 1833 report issued by the Catskill Temperance Society titled "Facts Showing the Evils Resulting from the Use of Intoxicating Liquors," the answer to the above question is fairly clear: it wasn't good. Highlights of the report include the following observations:

- There were, in Catskill, 130 habitual drunkards (one in 17 of the total population);
- Additionally, there were three hundred more individuals who were "publicly known to be drinkers of ardent spirits"; and
- In Greene County as a whole, the report offered that there were 1,700 habitual drunkards and 4,000 more who are "traveling in the way which leads to habitual drunkardness."

While it is, today, difficult to attest to the validity of the numbers offered, the figures cited, as one reviews statewide reports further, are not all that different than those given for adjacent counties. It is also important to note that the concerns expressed in the numbers were not merely for the health of the individual taking to drink but for the impact such behavior was having on this and other small villages throughout the Catskills. As the report goes on to state, when citing the numbers of those labeled as "habitual drunkards," "Many of those are heads of families who might have been in easy and honorable circumstances. In many instances their children are suffering with cold and hunger, their wives are sinking in despair." And, while the report also questions whether "our town and village authorities might any longer sell licenses for opening the fountains of sin, and pouring forth rivers of pollution and death upon our community," there is, within the references made toward "wives and children," an important link to the actions Ruth Croswell's objection began to forge. For, in the rise of the temperance movement, concern eventually fell not only on those who drank, primarily men, but also on the broken marriages and families alcohol left in its wake. The abuse manifested itself in many forms—from violence toward women and children, psychological harm to the same and the lack of financial support for the family. Such abuses focused the spotlight on what many women already knew: there was, in the male-dominated world of the nineteenth century, no legal protection for the wives and children directly impacted by the abuses alcohol unleashed. As voices, such as Ruth Croswell's, began to be heard within the temperance movement, so too did the call for women's rights and legal protection for women begin to find firmer footing. Ultimately, as the path toward prohibition began to take on greater momentum, it did so by incorporating more women within the battle. As a result,

as women began to draw from the experiences with the temperance movement and the political knowledge they gained through that cause, the move forward toward suffrage became the beneficiary. Women such as Elizabeth Cady Stanton and Susan B. Anthony, for example, found their initial footing as both leaders and effective advocates within the rise of the temperance movement.

The course of history is replete with small, simple acts. When Ruth Croswell, a child of colonial America, spoke up that day in a small upstate village against serving alcohol at occasions as basic as a women's tea, she offered no more than her conviction, no more than what she thought was the right thing to do. She was neither the first, nor the last, to express such concerns. She neither launched a grand movement nor was it her intent to do so. And yet, within the limited geographical construct of her life, within the world she knew, her voice meant something.

It would be unfair, from the distance of almost two centuries, to assign motives to her thoughts and words. Perhaps they stemmed solely from her religious convictions; perhaps her voice had been inwardly freed the day she saw George Washington moved by cheering citizens as democracy embarked on its American journey. Whatever the reason might have been, the fact remains she acted—she spoke. Where her small voice ultimately led, it is difficult to know. But the question remains, had she not spoken—had there been silence—what might the consequences have been?

Ruth Croswell died in the home of her adopted daughter on January 7, 1862. The following week, in the *Catskill Recorder*, a successor to the paper her husband and his brother, Mackay, had begun so many years earlier, James Pinckney offered the following:

> *There is no one, of our inhabitants whose memory reaches back to the time when Mrs. Ruth Croswell became a resident of Catskill.*
>
> *More than three-quarters of a century ago, she made this place her home—when the red men were more numerous than the whites on the present site of the village and the regions beyond the Catskills were a far-off country.*
>
> *Armies of humanity have come up to the battle of life—have borne the heat and burden of the day, and have laid down beside their arms*

in endless rest. And still she has survived. Thousands, later than she, have commenced the journey of life—have trodden the world's dusty thoroughfare, and have gone to their eternal repose. And still she has lingered, until it almost seemed that busy Death had deemed he might well permit her to tarry in the world, one whom earth's cares could not too keenly vex, whom its sorrows could not too deeply depress., nor its folly or its sin either sully or corrupt. And now, she too, who so long awaited her appointed time, has taken the path upon which there are no returning footprints. She rests from her labors, and her works do follow her.

Indeed her works did follow her, as they do for all who possess the strength of their convictions and, when necessary, give them voice. Such are the eddies that fill the great stream of history.

Author's note: I appreciate the Vedder Research Library in Coxsackie, New York, for making research materials available for this essay, including Frazer Hilder's essay, "The Croswells of Catskill" (1968). As noted, statistics on the use of alcohol during

Temperance group from Catskill, New York. *Photo courtesy of the Vedder Library Bronck Museum of Greene County Historical Society, Coxsackie, New York.*

the eighteenth and nineteenth centuries can be found in Last Call: The Rise and Fall of Prohibition *by Daniel Okrent, New York: Scribner, 2010. Full text versions of* Chronicles of a Pioneer School from 1792 to 1833, Being the History of Miss Sarah Pierce and her Litchfield School *by Emily Noyes Vanderpoel,* James Pinckney's Reminiscences of Catskill, Local Sketches *and Washington Irving's* Life of George Washington *are available online.* "Facts Showing the Evils Resulting from the Use of Intoxicating Liquors" *can be found in the Permanent Temperance Documents of the American Temperance Society, 1835.*

Chapter 2
Clubbing

*Come with me to the Thanatopsis Club. They have some of the best
papers, and current-events discussions—so interesting.*
— *Sinclair Lewis,* Main Street

With the above invitation, Carol, the main character in *Main Street*
by Sinclair Lewis, is introduced to the one and only women's club
in Gopher Prairie, Minnesota—the town she hopes to one day "reform."
In the latter part of the nineteenth century and into the early twentieth
century, clubs for women saw rapid growth across America in towns both
large and small. Their purposes were varied, from social, to literary, to
political. Each club was unique unto itself, as were the communities in
which they met. They could focus on local need while, at the same time,
giving voice to opinions on the larger issues of the day. Topics might
range from philosophy, to history, to English poets, to local charitable
giving, to temperance, to the right to vote for women. For the women
who attended, such gatherings not only afforded solidarity but also the
opportunity to expand knowledge, to learn and give thought to issues
and to otherwise broaden their awareness of the world despite limited
educational opportunities and the inability to have their voices carry
weight in the voting booth.

Women in the Catskills were no different than their counterparts across the nation. They, too, gathered in the small towns, villages and larger cities that dotted the local landscape. Meeting in churches, halls and private homes, their membership typically included the wives of local civic, business, political and religious leaders. In some cases, such clubs formed the foundation from which local reform would spring; in others, little more than tea and pleasantries were consumed. Still, whatever their nature or purpose, they offered local women the rare opportunity for social and political discourse where, as proclaimed in the *Official Register and Directory of Women's Clubs in America* (1916), a woman's "ideals were elevated, her trust in eternal goodness and its purpose strengthened, and her own possibilities as a social and intellectual force were brought out and gradually molded into form."

In the years of activism just prior to the adoption of the constitutional amendments that would lead to Prohibition and the right to vote for women, the following clubs for women could be found throughout the Catskills:

Schoharie County
Cobleskill:
Woman's Christian Temperance Union (400). President, Mrs. Datus Quackenbush
New Century Club (53). President, Mrs. Albert Gallatin Monroe

Middleburgh:
Twentieth Century Club (24). President, Mrs. G.T. Young

Sullivan County
Monticello:
Suffrage Club (42). President, Mrs. R.J. Muller

Ulster County
Kingston:
Coterie Club (16). President. Miss Isabel Thompson, 9 Orchard St. City Federation Club (300). President, Mrs. Charles M. Moulton, 57 Elmendorf St.

Lowell Literary Club (25). President, Miss Mary Baker, 85 West Chester St.

Monday Club (25). President, Mrs. Charles E. De la Vergne, 303 Clinton Ave.

Political Equality Club (85). President, Mrs. Myron J. Michael, 44 Maiden Lane.

Saugerties:

Monday Club (24). President, Mrs. John A. Snyder, 1 West Bridge St.

Greene County

Cairo:

Monday Council Club (14). President, Mrs. Norman Howard

Catskill:

Monday Club (21). President, Miss Mabel V. Root, 49 Spring St.

Coxsackie:

Clio Club (15). President, Mrs. William A. Dumont, West Coxsackie

Monday Club (25). President, Mrs. Thomas H. Low

Village Improvement Society (144). President, Mrs. John L. Loutfian

Greenville:

Woman's Concordia Circle (31). President, Miss Grace Seaman

Freehold:

Literary Club (26). President, Mrs. R.S. Wilsey, R. F. D. No. 2

Delaware County

Delhi:

Equal Suffrage Club (100). President, Miss Marie Maples Preston

Village Improvement Society (135). President, Mrs. W.R. Millard

Hobart:

Women's Civic Club (50). President, Miss Dora Silliman

Early pamphlet describing the purpose and mission of the Hensonville, New York Woman's Christian Temperance Union. *Author's collection.*

Woman's Christian Temperance Union

Hensonville, N. Y.

MOTTO:

"O Woman! Great is Thy Faith: Be it Unto Thee Even as Thou Wilt."—Matt. 15; 28.

PLEDGE:

"I hereby solemnly promise, GOD HELPING ME, to abstain from all distilled, fermented and malt liquors, including wine, beer and cider, and to employ all proper means to discourage the use of and traffic in the same."

Sidney:
American University Club (57). President, Mrs. Marie W. Sadler
Monday Club (40). President, Mrs. F.H. McKinnon

Walton:
Civic Club (50). President, Mrs. William E. Henderson

Author's Note: Numbers in parenthesis represent the number of members in a specific club in 1916. For more information on women's clubs in 1916, the complete Official Register and Directory of Women's Clubs in America *can be found online.*

Chapter 3

The Crusader

Marion Bullard

No parent of a gifted child could have done more to develop and spread its fame than she did for her beloved Woodstock. Marion's was the brain and the heart that led every forward step the town took. She crusaded, she cajoled, scolded and exposed until she won for the town what she thought was necessary for its welfare and its growth.
—*Rose Oxhandler, 1955,* Publications of the Historical Society of Woodstock

S he was a woman in a town that never elected a woman to anything. She was a liberal in a town that could count the number of Democrats on one hand. And she was an artist is a town that took its time warming to artists. By all accounts, Woodstock could be forgiven if it never took note of the life of Marion Bullard.

And yet, when she died tragically just before Christmas in 1950, Woodstock was stunned. Writing about Bullard for the *Publications of the Historical Society of Woodstock*, Rose Oxhandler summed up the sense of loss that rolled down Tinker Street and echoed across the slopes of Overlook Mountain, "We were shocked and shaken for our village was truly orphaned by her going. She was one of those men and women of the past who have poured out their lives for Woodstock."

In reality, there were two Marion Bullards: the artist turned writer and the woman who rallied Woodstock, New York, to be better than it was. More importantly, there was one heart behind both. Through her art and through her causes, hers was a rare female voice. It was a voice that drove the creative self beyond where she thought she could go, and in doing so, it became a voice that would push the town she loved to do the same.

Marion Bullard was born in 1878 in Middletown, New York. Her parents, Octavia Godell Churchill and Richard McKay Rorty, had married in 1874. As described by her sister, theirs was an uncomplicated life wrapped within a small town that "had a pleasant, simple culture of its own" and where "to the old Walkill Academy came scions of 'country families,' many of them residents in Orange County since before the Revolution." Ironically, and in her first semiconnection with Woodstock, Bullard's family, while still in Orange County, became neighbors with the family of John W. Hasbrouck, grandson of Woodstock's first supervisor, Elias Hasbrouck.

It was at the academy that a young Marion began to pursue her art under the tutelage of a "valiant young" teacher named Miss Parker. As further described by Bullard's sister, Miss Parker "was wont to sally forth on Saturdays with a sketching class—maidens in straw sailors, ankle length skirts, stiff collared shirt-waists; boys in striped 'blazers' who came along less for art than to rescue these pretty companions from bulls, blacksnakes, barbed wire, brooks and like hazards."

Bullard's more serious pursuit of art was later undertaken at the Mechanic's Institute in Rochester, at Columbia's Teacher College and at Cooper Union.

In 1903, Albert Morrison Bullard, an electrical engineer by trade and an associate of her brother, Malcolm, entered Marion's life. While theirs would be a short-lived marriage—Albert would die only five years later—their brief years together prepared Marion well for the life she would eventually find in Woodstock. For it was, shortly after their marriage, that the young couple took up residence in a rebuilt stable along MacDougal Ally in New York's Greenwich Village. Among their neighbors, according to Bullard's sister, were the "sculptures James Earle Fraser and his wife Laura Gardin, Edwin W. Deming, and Mrs. Gertrude Vanderbilt Whitney."

Following the death of her husband, Bullard found her way to Woodstock by way of the Arts Student League, which had established itself upstate in 1906. Three summers passed before Woodstock called her permanently. In 1911, she became an integral part of the League's "Rock City group," joining other artists such as Henry McFee, Eugene Spiecher, John Carlson, Edward Thatcher, Walter Goltz, Andrew Dasburg and George Macrum in the pursuit of painting, exhibiting and living the life of an artist in a converted barn along Woodstock's Rock City Road. Writing later for the Historical Society of Woodstock, John Carlson labeled his companions as the "highbrow group," and in dissecting the group further, he noted that they gathered

> at Rock City, an obscure mountain crossroad, half a mile distant from the village…all seated on the famous stone wall, or around the community pump, busily talking shop, singing and playing the harmonica. Gayety was a habit with these, and most of them owed their creature-comforts and happiness to the ministering angel embodied in a dear old soul, the famous Mrs. Magee, for, in fair weather and foul, in sickness or in health, she stood ready to serve the youngsters with shelter, food, and sympathy.

The kindness of Mrs. Rosie Magee was a bit of an exception in Woodstock when it came to artists. At the time of Bullard's arrival, the sleepy Catskill Mountain town, known for little more than tanning, bluestone quarrying and a mountain house, was in a period of transition. Longtime Woodstockers, unfamiliar with the ways of artists, met the newcomers with skepticism, caution and, in some cases, outright hostility as they saw their town take on a new, and not necessarily welcomed, persona. As Alf Evers described in his book *The Catskills: From Wilderness to Woodstock*,

> *The young men and women who arrived to study at the Arts Students League had a startling effect on Woodstock eyes and Woodstock minds. They were not only lively and irreverent to their elders, but they were also heirs to the tradition of Bohemianism.*
>
> *Art and obscenity became inseparably associated in many Woodstock minds. Rumors of unspeakable goings-on among "the artists" flew*

about the town. When a few men's shirts were ripped in a burst of horseplay at an Arts Students League dance, sheriffs were summoned from Kingston to punish the case of "nude dancing." Righteous citizens peeped among the bushes along the Sawkill, which flowed through Woodstock, hoping to detect instances of "nude bathing."

Even Bullard's description of her arrival in Woodstock depicts an instance that would give locals pause:

There I was sitting high up in the horse drawn stage coach, waiting for Eddie, the driver, to get his weekly haircut, when out of Beekman's store came a few artists. Among them, (I found out later) were Allen Cochran, Henry Lee McFee and Walter Goltz. They looked up at the strange girl and my eyes popped with shocked surprise. They had their hair shaved in patterns, and to the conventional city girl I was then, it was an extraordinary sight. One had plaids, one polka dots and the third had on the back of his head a face—eyes, nose and mouth done in black hair!

Such was the Woodstock Marion Bullard found, and perhaps to her own surprise, where the "conventional city girl" would flourish. Soon, along with other female artists such as Evelyn Jacus and Margaret Goddard, she was a welcomed member of the Rock City group, and her paintings began to receive notice. Commenting on the uniqueness of her style, Helen Shotwell, wife of Woodstock's most noted citizen at the time, Dr. James Shotwell, offered in an essay for the Historical Society of Woodstock that

the tender haze of apple blossoms against a misty hill; the dark power of the Catskills before a silver, rain drenched sky; or the sparkling gaiety of a little French town; all were illuminated with her sense of singing beauty. Her color was poetic and distinguished. She used gray with the elegance of the French painters and her skies and horizons had another dimension. She broke away from the tradition of landscape painting inherited by American artists from the French impressionists and painted directly, out of her own deep feeling for the world around her.

Helen Shotwell wasn't the only one who noticed. Soon, Bullard's works were finding their way to exhibits in prestigious places. Her work hung in the Pennsylvania Academy, the National Association of Women Painters and Sculptors, the National Academy and the Architectural League. She presented a one-woman show in 1923 at New York's Ferargil Gallery, and in 1928, she joined other Woodstock artists at the R.H. Macy Galleries where, noted the *New York American*, "The work of Marion Bullard is the chief attraction."

Creativity, however, is not always orderly nor is it always content. Such was the case for Bullard who, in the 1920s, began to turn her imagination to the writing and illustration of children's books, many with a decidedly Woodstock connection. Published primarily by E.P. Dutton, her stories, in addition to staying close to home, were populated by an imaginative collection of animals. In the *Sad Garden Toad*, for example, the plot unfolds in a garden along Bullard's beloved Rock City Road. *The Travels of Sammy the Turtle* saw the book's hero traveling to New York City and returning to the Catskills' Ashokan Reservoir, while the action in *The Hog Goes Downstream* centers around the Woodstock flood of 1924. It is noted that all ended well for the hog.

It was also during this period that Bullard's life began to shift from her art to a larger community purpose and challenging a town that was not used to being challenged. That she was an "artist" was one thing; that she was a "female artist"—and a "liberal" to boot—was quite another. But, for the next twenty years, despite the frustrations inherent in her position, challenge she did.

Around 1930, Marion Bullard began to write a column about Woodstock for the *Ulster County News*. The column, appropriately enough, was called Sparks. Not long after, her writing would expand to include responsibility for the entire Woodstock section of the paper. Marion Bullard had found a platform, and she would not hesitate in using it. She would joust at windmills, and if possible, she would pull the rest of the town right along with her: "We could do with a Jeremiah to stir us out of our indifference in this town. The Republicans feel so sure of reelection that they don't lift a finger, and the Democrats, knowing they have a small chance of getting in do less. Democracy is hard work and demands of each one something more than a shrug of helplessness."

Marion Bullard and "the boys." *Photo courtesy the Historical Society of Woodstock.*

While not shy about fighting and charging into battle with Woodstock Republicans, Bullard was an equal opportunity chastiser. Early on, for example, she waged a campaign to open town board meetings to the public. Upon winning that fight—no small feat in a closed political town—she was, according to Rose Oxhandler, equally "outraged" when "people didn't care enough to attend."

Bullard also battled for fiscal accountability and the simple premise that the citizens of a town have a right to know what the village fathers were spending their money on. Along the way, she was also quick to point out hypocrisy when she saw it rear its ugly head. This was particularly true in 1934 when she witnessed Woodstockers, on one hand, wearing their patriotism on their sleeves but, at the same time, threatening "to tar and feather any person daring to bring up the subjects of Socialism, Communism, or Fascism."

While the town of Woodstock was the primary front for the battles she waged, Bullard's concern for the land beyond her hometown also

41

drew her attention. Marion Bullard hated billboards, and she wanted them gone from the Catskills. As a result, she wrote and complained to any elected official she could find—whether they resided in Washington, Albany or locally. Failing to achieve their extinction, she proposed that they be taxed, preferably based on their dimensions. She wrote letters and complained to those businesses that would dare use a billboard as a means of advertising, and at the same time, she urged consumers to boycott those same businesses.

As her children's books might indicate, her concerns were not always political or always involving people. Bullard would write regularly in support of the proper care and treatment of animals, and in this regard, let it be known, "If anyone abuses animals in my bailiwick, I can be about the meanest woman in Ulster County." Woodstock's supervisor at the time, Albert Cashdollar—a man who, himself, gave no quarter—was on the other end of Bullard's passion one day when, after learning of the successful development of a new vaccine against rabies, Bullard secured from the foremost symbol of Woodstock power an agreement that every dog in Woodstock would be inoculated.

It was that same power structure, as represented by Cashdollar, that would be the focus of one of the more important civic improvements pushed by Bullard. Fearing disease and even "epidemics" from polluted wells, Bullard undertook a campaign for the construction of a proper water system in Woodstock. Underscoring her tenacity, Bullard would work tirelessly for four years before the town board finally voted to plan and construct such a system.

In the same year that Marion Bullard took up her campaign for a water system, she also became an advocate for another idea that, considering her opposition to things such as billboards, seems a bit at odds with the general direction of her environmental concerns and her appreciation of the landscape: an airstrip for Woodstock. At the time, immediately following the war, there was much debate in Woodstock over a proposal that would see such a strip constructed in the area known as the Bearsville flats. Bullard was for it. In fact, it seems, Bullard had warmed to the benefits of technology and the machines that became possible during the postwar economic boom. She wrote, at the time, "I remember when electricity first came to Woodstock. I was appalled at the thought of poles

standing all over the landscape and refused to sign up on the grounds that it would ruin Woodstock for the artists. And now, I have a small house chuck full of electrical gadgets that I couldn't do without."

In 1947, she would embrace technology even further and, in doing so, expand her opportunity to spread the gospel according to Marion Bullard. So it was, on June 22, that Bullard first took to the airwaves with a new radio program over Kingston's WKNY. She wasted little time taking on yet another cause as she began to push the Woodstock Town Board toward providing a proper name for Woodstock's main thoroughfare. At the time, and not unlike other towns in America, Woodstock's primary street was called, simply, Main Street. That wasn't good enough for Bullard, and she urged a return to the two names that that had once served Woodstockers just fine. And so it was, recalls Rose Oxhandler, that the town board

> voted to stop calling the principle artery Main Street, and restored the old name of Tinker Street to the road running from the village green to Bearsville. It was also agreed that the road going from the village green to Saugerties should be known as Mill Hill Road. Tinker Street got its name from the Tinker Shop owned by John Bradshaw who was an odd character and very clever at his trade. He claimed he could mend anything by the 'tinker process.' Mill Hill Road got its name from the grist mill which is now the Woodstock Country Club and was then known as Dibble's Mill.

One of the final battles that would engage Marion Bullard's energy and passion was on behalf of Woodstock's children. As late as 1949, she continued to urge the building of a new elementary school in Woodstock, making obsolete the scattered system of one-room schoolhouses still in place. It was a crusade she had joined six years earlier during the height of World War II when she wrote,

> Five years from now the babies of 1943 will be ready to attend school. We should have ready for them a school built on the foundations their fathers are now even making sacrifices for, freedom and Peace. A new school for Woodstock should be a memorial honoring all those in the

Township who have fought for freedom in all the wars including the Revolutionary War. This building could stand with a sculptured façade with freedom as its theme, facing Overlook Mountain.

In 1949, the majority of Woodstock voters agreed with Bullard, and a $220,000 bond was approved for the construction of a new elementary school. It was a victory, however, that Marion Bullard would never see to completion.

On Monday evening, December 18, 1950, after noticing Bullard's Sunday papers were still on her porch, Louise Linden summoned friends and neighbors Fred Mower, Kathryn Mower and Charles Rapp to help investigate. Upon entering Bullard's home, they found a shocking scene. In a report later issued by the state police, Marion Bullard's body was found fully clothed and partially submerged in twelve inches of hot bath water. According to police, and as reported in the pages of the *Kingston Daily Freeman* on December 19, there was "no evidence of foul play," and that it appeared Bullard "had drawn a tub of hot water preparatory to a bath when she fell into the tub after being seized with an attack of some kind."

The crusades had ended. The colors on her canvases were without their guiding hand. The animals in her stories would know no further Woodstock adventures.

No one loved Woodstock more than Marion Bullard. She had arrived as a young woman on the heels of personal tragedy determined to make something of her life as an artist. Along the way, she discovered that she could apply that same determination to bettering the town she cared so deeply for—a town seemingly wrapped in the need to maintain the status quo, a town of division, a town doing things the way they had always been done simply because it was easier. That wasn't good enough for Marion Bullard. And though she would never hold elected office, her "cajoling" and her "scolding" moved Woodstock forward in ways that demonstrated the power of one woman's determination. While art had provided the foundation for her life, Woodstock had become the reason for that life. Recognizing this, and understanding the two masters that moved her through the years, Marion Bullard wrote,

It is difficult to believe that Woodstock is true unless you come and live in it. Even Woodstockers themselves rub their eyes as they watch quota and quota being met. New progressive projects swinging through to success. Woodstock artists carrying off the big prizes of the year. Woodstock musicians ranking at the top and Woodstock writers making the headlines with literary critics. But all this is FLUFF compared with the bed rock quality of Woodstock as a whole. The fertility of its imagination, its persistence and its ability

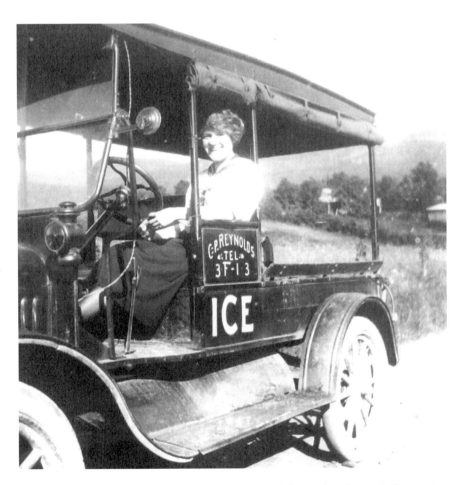

Following the passage of the nineteenth amendment and the continued struggle for equal rights between the two world wars, women began to take on new roles, even in the rural, conservative Catskills. *Photo courtesy of Frederick Allen.*

to work together for the good of all. Some of the finest minds of today are working and building for a future America right here in this Woodstock valley.

Author's note: Woodstock would elect its first female supervisor in 1972. Additional reflections on Marion Bullard can be found in Woodstock Years, *a publication of the Historical Society of Woodstock (2003), and in* Publications of the Historical Society of Woodstock, *vols. 59 and 17. For information on the life and death of Marion Bullard, see the* Kingston Daily Freeman, *December 19, 1950.*

Chapter 4
Surviving—Day to Day

Heroic Women
Encounter of a Mother and Daughter with a Bear
The Heroines Victorious
—Correspondence from the New York Herald, *Delhi, N.Y. December*
29, 1875

Author's Note: The following New York Herald *article, reprinted in its entirety, offers a glimpse into the inherent dangers of rural life in the Catskills and the daily struggles faced by all family members regardless of gender.*

Two women, mother and daughter, named Butler living on that spur of the Catskills of which Mount Prospect is the termination, recently had an encounter with a bear, in which manifested a heroism worthy of those early days in American history when the settlers were compelled to be continually on the alert against ferocious beasts and still more ferocious Indians.

Mrs. Butler is a woman about 35, and her daughter Jennie is 16. It is the custom of the husband and father to be absent in the woods sometimes two or three days, leaving wife and daughter alone with a good watch dog and rifle in the cabin. He was away on Sunday last. About 5 o'clock

on that day the daughter, Jennie, was preparing the evening meal for the hogs, which were squealing in the pen, a log inclosure a short distance from the house. A sudden change in the cries emitted from the sty, and the furious barking of the dog Joe caused both mother and daughter to run to the door of the cabin and look out. What was their amazement was a black bear with a shoat weighing about sixty or seventy pounds tucked under one fore leg and trying to climb out of the inclosure. The Butlers had lost three hogs already by the inroads of bears or other animals, and the women resolved to rescue this one if possible. The dog was making a great fuss on the outside of the pen but was afraid to jump inside and attack the bear. Mrs. Butler seized a heavy maul, used in driving wedges in logs, and her daughter snatched the ax from the wood-pile, and the two moved at once to the pen. They both jumped inside the inclosure, emboldened by which the dog also leaped over and commenced harassing Bruin in the rear. The women rained blows heavy and quick on the bear, which presently dropped the pig, and, turning on the dog, had him in his embrace in a twinkling and crushed him to death. The efforts of the women to dispatch the bear were redoubled. The bear was now raging with fury, and advanced with his jaws distended upon the girl, who was wielding her ax unmercifully. With one sweep of his great paw he struck the weapon from her hands, and the next instant had pressed her into a corner of the pen; but the horrible blows that were showered upon him by Mrs. Butler with the maul forced him to leave the girl before doing her any great injury. He rushed furiously upon Mrs. Butler, who managed to elude his grasp and retained possession of her weapon, which she used to good advantage. She shouted to Jennie to hasten to the house and bring the rifle and shoot the bear. The girl jumped from the pen, her clothing nearly all torn from her person, and hurried after the gun. The blood from the wounds inflicted on the bear by the ax and maul poured on the floor of the pen, and over the shaggy coat of the monster. Round and round the inclosure the contest waged, until at last the bear struck the woman's weapon with his paw, and sent it flying out on the ground. He pressed Mrs. Butler into a corner, where she dropped in a crouching position, and placed her hands over her eyes expecting to be torn to pieces the next instant. Just then her daughter returned with the rifle. She pushed the barrel through a chink in the log and fired. The bear

staggered an instant on his haunches and fell back dead. The ball had entered and passed clear through his heart, as was afterward ascertained.

With the removal of the great tension on her nerves Jennie fell lifeless to the ground, and it was a long time before her mother could summon strength sufficient to climb out of the pen to aid her. She finally got to the cabin, and succeeded in restoring her to consciousness. Neither of the women was hurt to any great extent, the daughter having only flesh torn under her arms where the bear had seized her, and being considerably scratched about her body.

Chapter 5

Fire in the Sky

Tragedy at the Twilight Inn

During the heyday of the Catskill Mountain houses, it was not uncommon to see, in comparison to men, a disproportionate number of female guests, along with their children, in residence during the summer months. As historian Alf Evers noted in his book, The Catskills: From Wilderness to Woodstock, *"Many city men who supported their families on modest wages or salaries sent their wives and children to the Catskills so that they might benefit from the pure cool mountain air while they worked their jobs as usual, for the vacation pay had not yet been made part of American life." The Twilight Inn in Haines Falls, New York, was, tragically, no exception to the general rule when it came to the number of women in residence during the summer of 1926.*

The bridge game had ended at eleven-thirty that evening. At about the same time, an impromptu dance in the servants' quarters was winding down. By one-thirty, on the morning of July 14, 1926, most of those either staying or working at the Twilight Inn in Haines Falls had finally turned their attention to the matter of sleep. It was at that time that the shouts of "Fire!" began to echo down the hallways, piercing the dreams most had sought. In a matter of minutes those dreams turned to nightmares, as fire spread without challenge through the four-story wooden structure. There was little time and, for some, little that could be done.

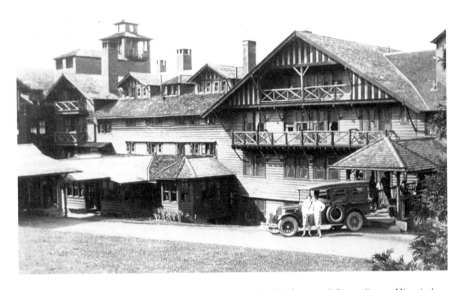

The Twilight Inn. *Photo courtesy of the Vedder Library Bronck Museum of Greene County Historical Society, Coxsackie, New York.*

As recounted by Mrs. E.A. Carter of Brooklyn in the *New York Times* the next day:

I was awakened by shouts outside the hotel. As I became fully awake I heard cries of Fire! Fire!

I jumped from my bed and ran to the next room, where my aunt was sleeping. I awakened her, then ran to my son's room and got him up. I started to dress, but the clamor below grew so loud that I ran to the door and opened it. I was met by a cloud of swirling smoke.

At that I gave up all idea of dressing. I doused a Turkish towel in water and wrapped it around my boy's face. Then I called to my aunt to follow and went out into the hall, carrying my boy in my arms. Flames were already running through the corridor, but though I was burned I made my way to the end and escaped down an outside stairway.

Not until I was safe below with my son did I learn that my aunt had not come with us. By that time the building was enveloped in flames and any attempt to rescue her was out of the question. Today I searched the hospitals where the injured were being cared for and rooms where guests routed by the fire had taken refuge, but I could find no trace of my aunt. I fear she is dead.

Mrs. Henrietta Ficken, Mrs. Carter's aunt, would be one of the twenty-two who would perish in the flames that consumed the Twilight Inn that night. Countless others would be injured. Twelve, however, would owe their lives to yet another Brooklyn woman, Miss Hannah Hyatt.

During the nineteenth century, as residents and businessmen alike began to turn their economic attention away from what they could take from the land to what others saw in that very same land, the dream of the mountain house began to take hold. "Modern" transportation

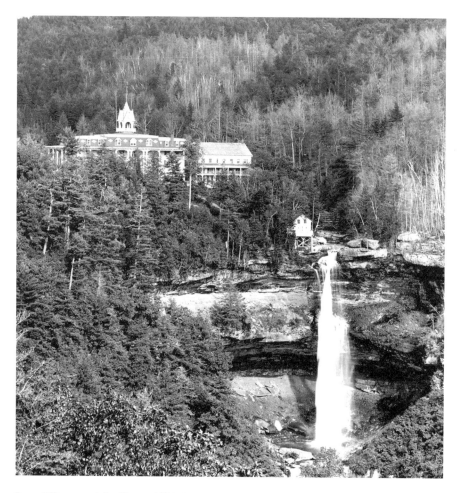

Laurel House and the Kaaterskill Falls. Constructed in 1852, Laurel House was uniquely situated near one of the première natural attractions in the Catskills, the two-tiered Kaaterskill Falls. *Image courtesy of Tobe Carey.*

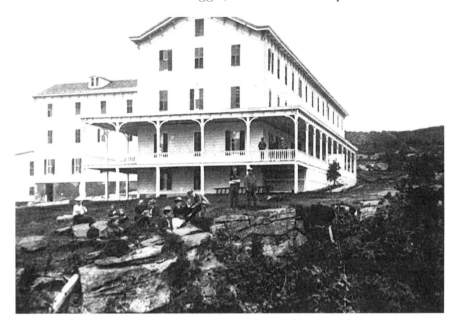

The Overlook Mountain House. First constructed in 1871, the Overlook Mountain House in Woodstock, New York, was twice destroyed by fire. *Photo courtesy of the Historical Society of Woodstock.*

in the form of rail and river travel now made the Catskills accessible to those in New York City seeking relief from the hot summers and unclean air endemic to nineteenth-century urban life. Spurred by the success of the Catskill Mountain House, constructed in 1824, others sought to offer that same relief and to profit from the sense of romanticism that had come to surround the Catskills. And so they came. They came to take up rooms in places such as the Hotel Kaaterskill, built in 1881 and expanded in 1883 to claim a capacity of more than one thousand guests. Laurel House was constructed in 1852 and expanded also in 1881. The Overlook Mountain House in Woodstock, New York, saw three different incarnations from 1871 to 1934, when work eventually ceased on the third and final version. Further to the west, near Pine Hill, the Grand Hotel opened its doors in 1881 offering, according to a *New York Times* review in 1885, the "only hotel among the Catskill Mountains reached by railroad and parlor cars directly to its doors, without staging, making the trip one of pure comfort and enjoyment."

For those who sought out the Catskills, theirs was a life detached from the reality left behind. High in the morning clouds, the well-to-do, socialites, bankers, the idle rich, authors, artists, women awaiting husbands to return on weekends and even presidents of the United States mingled as they took their meals and experienced the physical environment around them where, as an Ulster and Delaware Railroad advertisement offered, they were free to climb "to the breezy crest that pierces the clouds and (bathe) in the filmy vapor that flits up the mountainside."

Such were the mountain houses of the Catskills that greeted visitors for more than a century. Yet, despite the romantic, almost dreamlike atmosphere that surrounded their presence, there was another reality to their existence that was never noted in newspaper reviews or in advertisements designed to entice potential visitors—a reality presented by massive wooden structures perched on distant mountaintops and susceptible to the carelessly dropped cigarette or a bolt of lightning from above. It was the reality of fire.

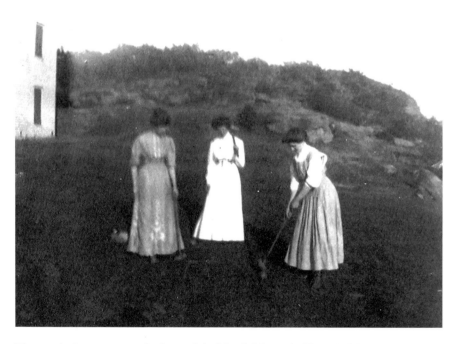

Women playing croquet on the lawn of the Mead's Mountain House in Woodstock, New York. *Photo courtesy of the Historical Society of Woodstock.*

That reality had left a calling card at the Twilight Inn a dozen years earlier, as an electrical fire threatened the lives of the 250 guests in residence. It was only through the determined efforts of hotel workers and local residents that the inn was saved. Working rapidly for more than an hour, a hastily formed bucket brigade managed to halt the fire before it made its way to the guest quarters.

A far more ominous purveyor of the inn's future, however, could be found in the fate other Catskill Mountain hotels that stood, piercing the sky, in defiance of common sense. Only two years prior to the fire that would tragically bring an end to the life of the Twilight Inn, the neighboring Kaaterskill Hotel, the largest of all hotels operating in the Catskills, was destroyed by a fire that began in its kitchen. Within an hour, the mammoth, one-thousand-room wooden structure was reduced to smoldering rubble. Nearby, in 1907, the four-story Squirrel Inn was lost to an early-morning fire causing more than 250 guests to flee. Further to the west, the Overlook Mountain House atop Woodstock's Overlook Mountain was lost to fire not once, but twice, first in 1875 and again in 1924.

Still, despite the dangers, the guests came. Only a year after the Squirrel Inn burned, it was rebuilt and featured, along with the Twilight Inn, in a June 1908 *New York Times* article titled "Flocking to the Catskills." Noting that the Twilight Inn had been "greatly enlarged" to include seventy-six new rooms, the article goes on to offer, "There has never been a time in the history of the Catskill Mountains when so many people were here during the last week in June, and the Inn has the greatest number of these people."

Eighteen years later, as the inn's night watchman began his rounds on a July night, the Twilight Inn, with the Kaaterskill Clove stretching beneath it, was still such a favorite. That all changed when Carl Stryker sounded the alarm that brought the first realization of danger to those guests and employees caught halfway between sleep and consciousness. For many, by the time they fully grasped the danger they were in, the fire had already moved in ways that would seal their fate.

On the upper floors of the hotel, an inferno had been unleashed by the dry burning timbers. Screams began to compete with the roar of the fire. Above the ground floor, guests in nightclothes became confused

and panicked as they entered the hallways, not knowing where an escape route might be found. Others, it is believed, lost valuable time as they attempted to gather their possessions before leaving their rooms.

For those caught on the upper floors, flames quickly surrounded them. One mother, attempting to flee with her two children, saw one fall into the flames—forever lost. Meanwhile, having sounded the initial alarm, Stryker, the night watchman, returned again and again to the hotel in an effort to reach those whose screams now rained down from the floors above. It is said that he reentered the burning building at least six times before his luck ran out. On his final attempt to reach those trapped above him, the floor beneath him collapsed, and the fire reached to engulf him.

Meanwhile, Harold Terns from Tannersville was struggling to reach those trapped inside as well. It is believe that Terns made at least five attempts to enter the inn at the height of the fire. His heroic efforts that night would lead to saving two people from the second floor and three from the first. Managing to reach the second floor despite the danger, Terns found a disorientated guest by the name of May Fleming. Throwing her over his shoulder, he began to descend down a fire escape only to have it collapse beneath them, fracturing Fleming's leg as they fell safely to the ground.

Up above, confusion and panic continued to reign. According to published reports, guests, unable to find their way out, ran back and forth through the smoke-filled corridors. One of those guests, however, seemed to find a moment of clarity in the midst of the terror and confusion. Later proclaimed by the *New York Times* as the "heroine of the fire," Hannah Hyatt was able to recall that a trap door on the porch nearby opened to a fire escape below. Attempting to take control over the panic that surrounded her, Hyatt began to direct guests to the escape door. Finding it stuck, the door had to be forced open so that access could be gained to the steps below. Twelve guests were saved as a result of Hyatt's quick thinking and her decisive actions that night. Hyatt herself was injured during the frantic escape, when, as she made her way down the fire escape, she fell and suffered broken ribs. Later, taken to a nearby hospital, she would fully recover.

Meanwhile, other women would also struggle that night against the heat and the flames in an effort to ensure the safety of others. Anna

Calash was seen running between the hotel's various cottages, attempting to wake those still asleep and warn them of the danger. Later, in the early morning, Calash would be found dazed and sitting on a porch without any recollection of what had happened or what she had done.

Unbeknownst to his wife, the inn's chef, Stephen Readlyn, had escaped the fire without harm. Thinking her husband was still inside, however, Readlyn's wife, who had also escaped safely, reentered the inn in search of him. Once inside, she, too, fell victim to the flames and was burned to death, as her husband, not far away, huddled with the other survivors against the chill of the mountain night.

Like most other guests, Mrs. Peter Martin also had her sleep interrupted by the shouts of "Fire!" Thinking quickly and recognizing the imminent threat to her location on the second floor, Martin grabbed her four-year-old son, John, and threw him out of a window to a rescuer waiting below. Climbing out of the same window, Martin then jumped the two stories to the ground, suffering a fractured elbow and leg, along with a number of lacerations.

Outside, local firefighters and police had begun to assemble. Along with those from Haines Falls and Tannersville, firefighters from Kingston and Catskill began to arrive as well. By the time of their arrival, however, there was little they could do. The only task left was to join in the attempt to save the many cottages and outbuildings that surrounded the burning inn.

Though she was not a guest in the hotel, Madeline Regan was also credited for her efforts that night as she worked to alleviate the pain and suffering of the Twilight Inn victims. Regan, a local nurse at the hospital in Tannersville, went without sleep for the next forty-eight hours as she tended to the needs of survivors. With room to handle up to seven patients at the hospital, Regan and others mounted an all-out effort to collect cots and bedding for the injured. Where possible, those survivors without major injuries were sheltered in the homes of nearby neighbors as the local community struggled to do what it could.

As morning approached, rain began to fall, aiding in efforts to prevent any remaining embers from reaching the surrounding buildings. When daylight finally did arrive, the eerie sight of only stone chimneys where once the Twilight Inn had stood greeted those who had begun efforts

to make sense of the tragedy and to account for the dead and injured. Relatives of the victims also began to arrive, including the father of Mary Holmes, a maid at the inn. Hoping that his daughter would somehow emerge from the smoke-tainted mist, he simply waited. There would be no miracles for him that morning.

As the morning of the next day lingered, the inevitable that often follows such tragedies began to unfold. Airplanes began to circle above to capture photographs; onlookers and hawkers gathered along the perimeter; state police officers began to sift through the rubble; guest lists were checked, revised and checked again; and a memorial service was organized for later that day at the All Angels Episcopal Church.

The dead were housed in the inn's plumbing shop, as relatives began the gruesome process of attempting to identify the bodies. In one such instance, the grandson of Mrs. Mary Eckenbrecker was given, upon his arrival, a wedding ring with the inscription, *To Mary from Cornelius.* The ring, in and of itself, told him all he needed to know. "She never would have removed the ring from her finger" was his only comment in acknowledging her death.

In the years that followed the Twilight Inn tragedy, as prosperity and peace gave way to the Depression and World War II, the great mountain houses of the Catskills begin to fade. Magnificent and unique as they once were, they would be replaced by easily accessible motels alongside major highways or, later, by quaint bed-and-breakfast establishments, offering the promise of, at least for a three-day weekend, a slice of "country living." Strict fire codes and advances in fire prevention would eventually arrive, making the tragedy of the Twilight Inn less likely to occur again. And the automobile would permit new adventures to tourist attractions designed to make the most of the uniquely American two-week vacation.

Today, car after car, especially during fall foliage season, pass by where many of the great hotels once stood. Save for the occasional historic marker or an exhibit at a local historical society, there is little to remember them by. And yet, thousands once flocked there. Oblivious to the reality such structures hid from them, they came, like Hannah Hyatt, to find their dreams in the sky. Unfortunately, for the dead and injured of the Twilight Inn fire, for those in the community who endeavored to do so much while risking their own lives and for the family members left

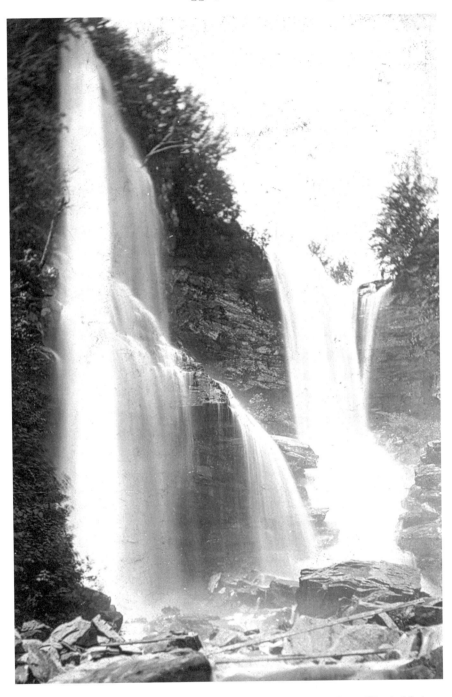

Haines Falls. *Photo courtesy of the Vedder Library Bronck Museum of Greene County Historical Society, Coxsackie, New York.*

behind, those dreams turned into nightmares as the inherent danger of the mountain house tragically revealed itself.

Author's note: This story was compiled primarily from various newspaper accounts reporting on the Twilight Inn fire, including the New York Times, *July 15, 1926, and the* Kingston Daily Freeman *of July 15 and 16, 1926. Thanks to the Vedder Research Library for access to George H. Peiffer's essay, "A Catskill Mountain Tragedy." Additional material regarding the era of the great Catskill Mountain hotels was drawn in part from Alf Evers's* The Catskills: From Wilderness to Woodstock, *Woodstock, NY: Overlook Press, 1982.*

Chapter 6
The First Lady Who Never Was

S he is listed by the White House as first lady to her husband, Martin van Buren, whom she married in Catskill, New York, on February 21, 1807. That said, Hannah van Buren never spent a night in the executive mansion nor saw her husband serve a day as president of the United States.

She had blonde hair and blue eyes and, like her husband, grew up across the Hudson River from the Catskills in Kinderhook, New York. Born to a solid Dutch family, she is remembered as being shy, proper, timid and, as noted by the *Albany Argus* on the occasion of her death, "an ornament of the Christian faith."

The future president was twenty-four when they married; she just a few months younger. Wishing to avoid a large celebration, Van Buren decided they would wed only before their immediate families and a close-knit group of friends. So it was that they made the trip to Catskill to be married by Judge Moses Cantine in a home owned by her brother-in-law.

He called her Jannetje, Dutch for Hannah, and by the few accounts that exist, Jannetje appears to have been a solid representation of the early nineteenth-century wife. Though a daughter would be stillborn, she would give birth to four sons. The fourth, Winfield Scott van Buren, died in infancy, as Hannah struggled to recover following his birth. In 1817, a

Hannah van Buren. *Author's collection.*

The house in Catskill, New York, where Martin van Buren wed Hannah Hoes in 1807. *Photo by the author.*

weakened Hannah van Buren, not quite thirty-six years of age, died after contracting tuberculosis.

Following her death and a brief period of mourning, Van Buren went on to establish and build his political career. He would, purposely, never speak of Hannah publicly again, including no mention of her in his memoirs. For more than a year into his presidency, Van Buren would serve without the benefit of a first lady or someone to fulfill that function. Only when his eldest son, Abraham, married Angelica Singleton did the eighth president find a hostess for his White House.

Van Buren would never remarry. Perhaps, in his heart and mind, no one could replace Hannah. As a result, the woman he married on that winter day in Catskill, New York, still holds her place in American history. While she never wandered through the many rooms of the White House, the memory and influence of the first lady who never was stayed with the president until his death in 1862.

Chapter 7
A Child of the Catskills
The Early Life of Candace Wheeler

Author's note: Unless otherwise indicated, all quotes are taken from Candace Wheeler's autobiography, Yesterdays in a Busy Life, *originally published in New York and London by Harpers & Brothers, 1918.*

She has been given such titles as the "high priestess of the Aesthetic Movement" and the "mother of interior design." And to her credit, Candace Wheeler's accomplishments were many. This child of the Catskills, born in Delhi, New York, would go on to found the Society of Decorative Arts in 1877, an effort to offer nineteenth-century women a means by which their traditional, handmade works and skills could be directed toward profitable ends. She would, over the course of her lifetime, author numerous books on interior design, needlework and gardening. In 1879, she teamed with Louis C. Tiffany to create the interior design company Associated Artists. They would claim, among their "clients" and decorating projects, Mark Twain's Hartford, Connecticut home and the White House. In 1893, she was named the director and supervisor of the interior decorations of the Women's Building at the Chicago World's Fair. And, returning to the mountains that nurtured her artistic and creative gifts, Candace Wheeler, with her brother, Frank, would develop in Tannersville,

Candace Wheeler, born in Delhi, New York, 1827, worked throughout her life to open economic markets for women through the application and sale of home-based arts. In addition to her personal achievements in the field of decorative design, she also founded the art colony known as Onteora in Tannersville, New York. *Author's collection.*

New York, one of the first art colonies in the Catskills. To be known as Onteora, Wheeler's gathering of artists, writers and intellectuals within the rustic beauty of the mountains she loved was, as Wheeler would offer, "the outcome of all I had learned and experienced during the first half of my life."

Candace Wheeler enjoyed a rare thing for a woman in the nineteenth century: success in her own right. And yet wrapped within that success was her underlying commitment to hard work and independence, attributes instilled at an early age as a child in the Catskills. Understanding the importance of that foundation and that she was not the only woman to posses both skills and talent in the traditional crafts, she worked faithfully to secure pathways for women into the arts and toward independent lives. With the building and evolution of Onteora, Wheeler would return to the Catskills, but as she would acknowledge throughout her life, her childhood and the lessons gleaned during those early mountain years guided her throughout her days.

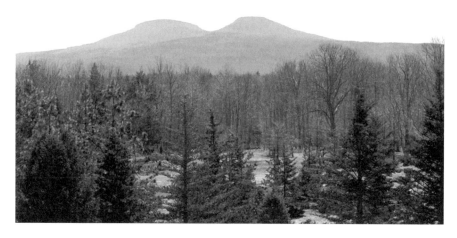

View from Onteora. *Photo by the author.*

She was born into a family of eight at a time and in a place where the future for young women rested squarely on the prospects of marriage. The idea of an independent woman was less than foreign—it was unknown. Writing later in life, she would note in her autobiography,

> *In the life of the country town where I grew up there were no girls of fortune and none who were self-supporting. There were one or two elderly single women who "helped themselves" by school teaching or giving inadequate lessons upon on the piano, and those two pursuits were the only ones open to unmarried women. The career of a powerful and competent single woman, as we know it to-day, was an unheralded dream. The curious, half-mysterious self-sufficiency of such women, together with its triumphant vindication by large results, was all in the future, and meantime we married, or waited, more or less impatiently, for our turn to come.*

She was the third of eight children born to Abner and Lucy Thurber. Her father, known as "Deacon Thurber," was an idealist and religious

enthusiast in the Puritan tradition who once desired a future as a missionary for his daughter. Certainly a woman of scripture, Candace's mother met the idealism of her husband with a more practical outlook. Described by Candace as a "domestic manufacturer," theirs was a home that did not want for food, clothing or the effort required to support such a large family in the heart of the rural Catskills. And manufacture they did: candle making, tapping and producing maple syrup, smoking and curing meat, pickling, farming and storing vegetables such as turnips, potatoes, carrots and cabbage and, with an early glimpse at Candace's future, needlework and the "spinning and weaving of cloth for the winter warmth of all of us."

Theirs was a busy and well-visited home as well, as missionaries were a constant and consistent presence. It was also a home very much in sympathy with the abolitionist movement—so much so that use of cotton was forbidden in any of the family's clothing. Other visitors to their home, Wheeler remembers, were of the quiet sort, as the Wheeler barn was occasionally used as a stop by black men making their way north. As Wheeler later recalled, she would see someone "first in the morning, having presumably arrived in the night. After breakfast and morning prayers he was sequestered in the haymow during the day, and disappeared during the night." Abolitionism, not being the most popular of causes within the community, would serve as a point of separation for the young Candace, recalling later, "that when the children of the school or neighborhood felt I was particularly in want of being 'taken down,' a favorite method of it was to call me the 'nigger queen.'"

What Wheeler's attitude toward blacks was later in life is somewhat clouded however by thoughts set forth in the pages of her autobiography. As she reflected on her time spent in Georgia and her new home, Wintergreen, she appears to have either moved away from the abolitionist sentiments she grew up with during her formative years in the Catskills or adopted thinking not uncommon among many Americans during the post–Civil War years:

> *I grew up in a mental atmosphere strongly tinctured with abolitionism and in a house which was one of the out-of-the-way stations of what was picturesquely called 'the underground railroad.' Slave life to me was*

then all tragedy, and there was no hint in it of the affectionate relation between slave and master which, I now know often existed. My child-mind was so dominated by the Puritan thought of wrong that the sense of it remained until the experience of years taught me that even wrong has alleviation, and that servitude on some form is a condition of life.

The "child-mind" Wheeler notes was also impacted during the years under her parent's roof by the proximity of death, which arrived in her small Catskill village in the form of spinal meningitis, which, as Wheeler recalls, "ran like a slaughterhouse fiend along the village streets." The medical arts being what they were in the pre–Civil War days of the nineteenth century, little was known about the disease, as members of the community were pressed into service in an effort to comfort the afflicted. Candace and her older sister were not excused, and they found themselves often caring for children whose parents had taken ill. So it was that a relatively carefree childhood, heretofore unvisited by death and grief, quickly became acquainted with the most difficult of life's lessons.

Both Wheeler's mother and father believed that death was a part of the natural of order of things and that it should not be hidden from their children. Thus in addition to her experiences during the meningitis scare, Candace and her siblings were, when a child died in the village, taken to view the remains as they were presented in the home of the grieving family. As a child, however, Wheeler's thoughts during such uncomfortable visits did not necessarily contemplate the larger meaning of life and death. Rather, as only a child can, she would recall admiring the beauty of the child that lay before her, "I wished I could be white and beautiful as they were, and thought their tiny frost-white hands with fingers folded into one another, the prettiest things I had seen."

Life in the Thurber home, as it stood across the river from the village of Delhi, was "different" than many families in the early to mid-nineteenth century. In fact, Candace described the Thurber household as being "a hundred years behind the times," living, as she believed they did, in a manner more befitting her New England ancestors of the eighteenth century. Reading material, for example, was selected and

proscribed by her father, as dictated by his work and his faith. As a result, the Bible was, as Wheeler labeled it, their "literary bread." Other books found on the Thurber bookshelf did not wander far from the established household themes of the practical and faith connected. Some of the texts that occupied the family library, as recalled by Wheeler, included Edwards Young's *Night Thoughts*, a ten-thousand-line poem in which the author, following the death of his wife, contemplates life over a period of nine dark nights. Also present was the ten-volume *The Course of Time* by Robert Pollock, a religious poem that ponders the destiny of man. More notable works, such as Milton's *Paradise Lost and the Fall of Man*, and the Christian allegory *Pilgrim's Progress* were also included as part of the family's reading repertoire. Of more utilitarian value, the Thurber library also included William Corbett's nineteenth-century guide to self-sufficiency, *Cottage Economy*, and *Sidereal Heaves*, a work on astronomy by Scottish minister Thomas Dick.

Wheeler's early experiences with reading, however restricted, would eventually open up her lifelong love of the written word, especially poetry. Despite curbs on what she could read, her father did encourage her pursuit of poetry and would, at one point, not only collect poems for her consumption but also provide Candace with a scrapbook, of sorts, "in which to paste stray poems which he gleaned from newspapers." Although she would not immerse herself in the works of Shakespeare and Dante until her marriage a number of years later, her father's tutelage would serve as a part of the intellectual foundation that would, one day, spark the development of Onteora and the nature of the acquaintances she would gather around her.

Formal schooling would come, primarily, from her time spent in attendance at the Delaware Academy in Delhi. One of New York State's oldest academic institutions, the Delaware Academy served as a highly respected institution of learning, boasting among its faculty a future United States Supreme Court judge in Charles Evans Hughes and, as a student, a future first lady in Ida Saxton McKinley. Many of its graduates went on to prestigious institutions of higher learning such as Yale, Princeton and Columbia. In the 1838 *Annual Report of the Regents of the University of the State of New York*, the institution's instructional practices were noted as follows:

The great object at which the principal aims in imparting instruction to the pupil is, to make their education both thorough and practical, and to learn them to think accurately and correctly, and to exercise reason and judgment as well as the memory. In the attainment of this object less regard is always paid to the quantity learned than to the manner in which it is acquired.

With the above noted, the extent to which young women were provided the same academic opportunities as their male counterparts is made questionable by the report when it also notes, "Painting, drawing and music are also provided in the female department." Though distinctions were clearly made between which gender should study what subjects, the opportunity for Candace to expand beyond her father's limitations and explore the world of the creative arts had to be welcomed by the young designer in waiting. To be fair to her father, however, it should also be noted that there was no requirement that he provide his daughter with any formal schooling.

Within the realm of the arts, music, poetry and literature also played an important part in Wheeler's early years. As a young girl, Wheeler and her siblings could "read music as easily as (they) read books." In addition, there was also a certain liberation in the music she and her family enjoyed, as her father's restrictions on what was permissible seemed to relax when it came to the songs the family joined in offering. While music with a decidedly religious orientation made up a good portion of the family repertoire, love songs and the melodies of Irish poet and songwriter Thomas Moore were also included. Together, members of the family offered a wide range of musical ability. Wheeler was a contralto, her older brother a tenor and the oldest sister a soprano. While her father would supply the bass they needed, the musical "star" of the family appears to have been the youngest sister, Lucy, "the beloved song-bird of the family."

Beyond their "in-house" musical education, the Thurber children also found most Saturday evenings dedicated to attending "singing-school." Walking the mile from their home to the Presbyterian church, the Thurber children received instruction in "sight reading and choral music by 'a professor' who lived in Albany." On their way home, walking back to

the small farm across the river, they would continue their singing as they made their way past the darkened homes of their Delhi neighbors. In her later years, Wheeler remembered, "If anyone was awakened from early toiled-earned sleep by our fluting and singing, they probably explained the disturbances by saying, Oh it's only them Thurbers going home from singing-school."

The Thurber kids—raised differently than their Delhi schoolmates—had a unique childhood in a unique home. Born to a mother who, as Candace described, "manifested all the human and practical virtues," and a father who "supplied the heavenly fire which sacrificed them," they lived a life based on scripture and Puritan ways. Theirs, indeed, was a different life. A life, at times, that presented a young Candace with the knowing sting of deprivation and a sense of separation from her community. And yet, she would eventually come to appreciate the fullness of what she had and would, over time, understand the gifts she had unknowingly received.

> *Every separate year of living with nature, together with the companionship and teaching of my nature-loving father, was destined to be an enrichment of the future. I grew up into early girlhood, drilled in all the expedients, economies, and accomplishments of pioneer and country life, taught to spin, to sew, to knit, to cook, and to housekeep by my wonderful mother, badgered and gibed into becoming humility by my active brothers, learned in maternal duties through the enforced care of a succession of brothers and sisters; and so, perhaps, when the future arrived, I was not altogether unprepared for it.*

The future for Candace Thurber arrived in the form of an introduction to Thomas Wheeler. Within a year of a first meeting arranged by friends as she visited New York, she was his wife. One year later, at the age of seventeen, she became a mother. Three other children would follow, as would a full life of developing as an artist, honing her skills as a designer and venturing into various enterprises within the decorative arts. Following her successful partnership with Louis C. Tiffany in the textile firm of Associated Artists, she went on in 1883 to inaugurate her own textile-design business and successfully negotiate her way through a

world that had previously been dominated by men. Of equal importance, however, was her work with the Society of Decorative Arts, begun in 1877, and, a year later, the creation of New York Exchange for Women's Work. Reaching back to the lessons of her childhood, Wheeler began to labor diligently for the economic liberation of women by turning the "domestic" skills they possessed into a means of producing viable, artistic commodities. As noted in the mission for the Society of Decorative Arts, its prime objective was to "encourage profitable industries among women who possess artistic talent, and to furnish a standard of excellence and a market for their work." The women's exchange dedicated itself to an even broader, yet similar, purpose. Inclusive of all women, the exchange operated on the principle of encouraging women to sell all products, not just those associated with the decorative arts, that they could produce in their own home—from pies to linens. In a post–Civil War America, where a large number of women had lost husbands or fathers and the economic support they traditionally provided, self-sufficiency became even more a pressing necessity.

As Wheeler remembered,

> *Women of all classes had always been dependent upon the wage-earning capacity of men, and although the strict observance of the custom had become inconvenient and did not fit the times, the sentiment of it remained. But the time was ripe for a change. It was still unwritten law that women should not be wage-earners or salary beneficiaries, but necessity was stronger than the law. In those early days I found myself constantly devising ways of help in individual dilemmas, the disposing of small pictures, embroidery, and handwork of various sorts for the benefit of friends or friends of friends who were cramped by untoward circumstances.*

More than forty years after she left Delhi, Wheeler would return to the Catskills with her brother, Frank. On the day she first viewed the land that would become Onteora, Wheeler, as her brother went off to negotiate the property's price, sat and contemplated the beauty around her. Drawing a volume of verse by John Greenleaf Whittier from her pocket, she read the following from *The Tent on the Beach*:

They rested there, escaped awhile
 From cares that wear their life away,
To eat the lotus of the Nile
 And drink the poppies of Cathay;
To fling their loads of custom down,
Like drift-wood, on the sand-slopes brown,
 And in the sea-waves drown the restless pack
Of duties, claims and needs that
 Barked upon their track.

Upon returning to his sister, Frank announced, "I have bought the farm."

Wheeler read her brother the verse from Whittier. "You see," she said, "he felt the same way we do."

And so the building of Onteora commenced. Its purpose was a decidedly simple one: to "satisfy the Instinct of Happiness." Soon rustic cottages began to rise, with Pennyroyal and Lotus Land being the first. Other buildings, including more cottages, an inn, a church and a library would follow, as an expanding circle of friends, artists and writers began to find their way to the remote mountainside. In addition to summer visits by Mark Twain and the occasional appearance of John Burroughs, Onteora residents included, at one time another, painters Carroll Beckwith and Jarvis McEntee, Columbia professor Brander Matthews, editor Richard Gilder and the president of the national Academy of Design, John Alexander. Women were an equally vital part of life at Onteora. Among those most intimate with the mountaintop setting was Elizabeth Custer, wife of General George Armstrong Custer, who following the general's death had turned to writing books of western motif; she first arrived at Onteora in 1894. Maude Adams arrived in 1900 already established as one of America's première actors, having won acclaim for her performance of *Peter Pan*. Mary Mapes Dodge built her cottage, Yarrow, at Onteora in 1888. Dodge, the editor of the popular children's magazine *St. Nicolas* is probably best known for her work *Hans Brinker, or the Silver Skates*. In light of Candace Wheeler's life and the independent course she chartered, it should be no surprise that the women who found their way to Onteora were of like mind and strengths.

Onteora cottage of actress Maude Adams. *Author's collection.*

All Souls Church at Onteora. *Photo by the author.*

Independent through their work, they drew upon their talents to sustain themselves and their lives, serving the cause of women, like Wheeler, through what they produced each and every day.

They lived, in more ways than one, in rarified air, as creativity and intellect combined with the physical power and beauty that surrounded them. They worked, played, offered picnics during the day and danced by night. As Wheeler recalled later in life, they were indeed a close-knit group that shared their creative and intellectual abilities in a spirit enhanced by their physical surroundings:

> *The chosen people who came to stay at the Inn and who built small cottages on beauty spots on the eastern and southern faces of Onteora Mountain used to gather at night in the main room of the inn. Mark Twain and Jamie Dodge—who surely had the gift—told stories, Laurence Hutton and Brander Matthews contributed their share of the entertainment, while the* Century Gilders *and some of our beloved painters smiled, laughed or listened.*

It would be hard to imagine, during such evenings, that Candace Wheeler would not have thought back to the times her family spent together so many years ago in Delhi. Perhaps, it was the singing Thurbers that came to mind or images of her mother working a needle and thread. Wheeler had wandered far from that little farmhouse. Or had she? In many respects, the childhood Wheeler had forged in the heart of the Catskills led her right to where she wanted to be. She had moved beyond where her mother had ended. She had taken the gifts of her childhood and not only grew as an independent woman but had willingly shared those same gifts with others. Hers became a life of example, illustrating not only that transition out of the home and into the workplace was possible but that the skills a woman possessed could lead to reward and respect.

When she died in 1923 at the age of ninety-six (her husband died twenty-eight years earlier), Wheeler had begun to see the fruits of her labors. Women had obtained the right to vote, and more and more were exerting their influence outside the home. While her own notoriety faded as she moved into the silence of old age, the path she established was

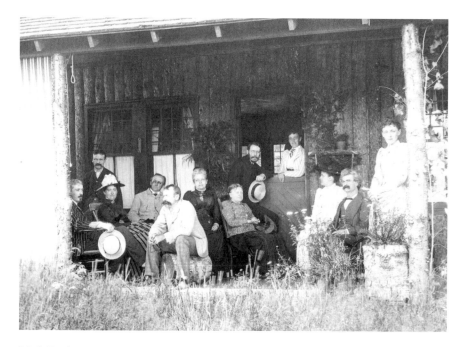

Mark Twain *(second from right)* with Candace Wheeler *(seated, center)* at Onteora. Though the actual order of all in the photo is unclear (except where noted), the signatures appearing at bottom include James Carroll Beckwith *(far left)*, W.F. Clarke, Mary Elizabeth Dodge, Lillie Hamilton French, Laurence Hutton *(fifth from left)*, Brander Matthews, Richard Heber Newton and Dora Wheeler. Twain rented the cabin at Onteora known as Balsam. *Photo courtesy Graphic Arts Collection, Department of Rare Books and Special Collections, Princeton University Library.*

being followed by more and more women. As a child in Delhi, New York, a young Candace would worry about what was to become of her. Little did she realize—little do we all realize—that at the center of those younger years rests the learning and understanding we take with us into adulthood, the tools by which we are able to direct the course of the days to come. So it was in the Wheeler home. From all "the manufactures that were accomplished there," from the "moral and mental standards" that were established there, came a life that would create a difference—a difference crafted in a small Catskill Mountain farmhouse that would take on the world quite nicely.

Chapter 8

The Ordeal of Mrs. Coleman

In his 1873 *History of Sullivan County*, James Quinlan offered a chilling question as he documented the horrific story of one woman's personal nightmare along the Catskill frontier—a nightmare that stemmed from a clash of cultures throughout the Catskills—as natives and settlers alike set out to ensure each other's elimination. "How little do the mothers of Sullivan at the present day know of the perils and suffering of the women who first came to this region with their loved ones! Who can estimate the grief of this woman, when she saw her little one thus murdered, and its body left to be torn to pieces and devoured by wild beasts?"

Quinlan's story centers on the plight of a woman identified only as Mrs. Coleman. Yet, despite her anonymity, her story is reflective of a time and place when the Catskills served as this nation's western frontier and, as a result, center to an ever-moving battle line between two diverse cultures: one looking to expand westward and the other forever struggling to hold on to what had always been theirs.

In its telling, the story of the Colemans unfolds like a Hollywood movie. It is only when we begin to internalize the human horror that was its reality do we begin to comprehend the danger that was at one time present across the Catskills, a danger known all too well by white settlers who took on the challenge of clearing land and crafting homes against

the edges of the frontier. So it was with the two Coleman brothers, their wives and their combined seven children. Together the two families occupied a lone log home near the village of Burlingham. On a Sunday afternoon, while one brother lay confined in his bed with illness, the other went in search of horses that had strayed. Lying in wait, a small band of natives shot and scalped the first brother before moving toward the home and the remaining family members. Without entering the cabin, however, and by inserting their rifles in spaces between the log courses, the attacking party managed to shoot and kill the other brother as he rested in bed. Storming through the door, the Indians proceeded to drag the dead man from his deathbed and scalp him in full view of the now widowed women and fatherless children. Preparing to flee, with the women and children as captives, the Indians ended their raid by setting fire to the buildings the Coleman brothers had labored to build out of the wilderness.

Recognizing that one of the women had recently given birth, the natives set her on a horse with the infant in her arms. As the party of Indians and captured women and children made their way in a northwest direction, the infant began to cry, risking the threat of discovery by any search party that might be near. Warned that she must keep the child silent, the mother endeavored to do all she could to comply with the demands of her captives, a task, as any mother knows, that becomes almost impossible the more one tries. The baby would not remain silent. Unable to risk the possibility of discovery, one of the Indians proceeded to rip the still crying infant from the mother's arms, end its life with one swift stroke and toss the lifeless body deep into the woods. The mother, left astride the horse she was bound to, and the children who remained were left to silently absorb the horror and the pain of the infant's death. Onward the small party pressed, passing through the Mamakating Valley as sunlight faded and darkness surrounded them.

As the dawn of the next day approached, exhaustion, soreness and pain from the physical demands of their journey began to take hold. Still, the natives pushed, relentless in their movement toward a destination that would be safe from capture and reprisal by white settlers who were surely already searching for the women and children they held captive. They were correct in their assumption. For while morning came upon

the Indians and their captives, that same dawn saw the departure of a search party of men from nearby settlements. Following the hoof prints left by the horses of the retreating Indians, the trail was quickly established, and the pursuit was on. As the day passed, determined in their relentlessness, the would-be rescuers closed the gap quickly. By evening, though unknown to them, the search party was almost upon the Indians and their captives as they maneuvered somewhere along the banks of the Delaware River. Aware that their pursuers were close behind, the Indians turned off the path and onto landscape where hoof prints could not be left. Hiding in a nearby thicket, the Indians watched in deadly silence as the search party passed nearby. The proximity of the two parties, at one point, was such that the natives and their captives could hear the voices of the would-be rescuers.

As Quinlan wrote, "The very tones of this or that neighbor could be distinguished. But the poor children and their mothers did not dare look in the direction from which the friendly sounds came. Every savage held in his hand a weapon with which to dash out their brains if an alarm was made, and every eye of the red men gleamed with deadly determination."

Realizing the Indians had abandoned the trail they were on, the search party, unable to locate evidence of a new direction, was forced to return home as darkness fell. Remaining cautious, the Indians decided to remain shielded for the evening in the thicket that had served them so well. From the time the party had left the Colemans on Sunday, however, they and their captives had gone without food. Fearing the sounds of their guns firing at game might alert a rescue party, they continued their journey until Tuesday, when they finally decided it was safe enough to shoot and take a deer. As they traveled, it appears they encountered the waters of both the Delaware and Neversink. Still on horseback, Mrs. Coleman was placed at the head of the column as they attempted their crossings. She was, in her state of weariness and shock, very much the proverbial "canary in the cage" as she and her horse tested the depths and currents of the waters before the Indians proceeded further.

Sensing they were free of discovery by settlers in search of the Colemans, it appears, according to Quinlan's account, that the next two days were spent in an almost "leisurely" march toward their home encampment. Following their travels, which, as Quinlan believes, took them some forty

to fifty miles past the Delaware River, they arrived home to a welcoming greeting during the evening hours of either Wednesday or Thursday. Once safely in their encampment, the humiliation of the captives did not end. With their mothers looking on, helpless to do anything to stop the torment, the children, naked, were forced to run circles around the center fire as Indians followed whipping at their bare skin.

It was here that Mrs. Coleman, having already lost one infant to murder, could no longer bear her ordeal. With the screams of the children echoing through the night air, helpless in her ability do what a mother should do, she bolted from the camp and into the night where, according to Quinlan, "she could breathe away her life, and witness no more horrors."

In the darkness, not knowing her fate, she stumbled through the woods until a light in the distance beckoned her. Despite her condition, she managed to move toward an isolated wigwam where an elderly English-speaking squaw whose name we know only as Peter Nell met her. The old woman, upon hearing Mrs. Coleman's story, began to treat her with the "first kindness" she had known since that horrible Sunday of the past week. Over a period of time, as she cooked for her and nursed her, the old squaw slowly brought Coleman back to health and would, eventually, aid her in her return home.

While the ending to this tale of pain and horror proves to be a good one, in some respects, for Mrs. Coleman, we are left not knowing the fate of the other captives. Quinlan notes in regard to the children that, "It was reported many years afterwards that two or three of them escaped, but there is no certainty." Still, the Coleman ordeal is illustrative of the danger that once existed in and around the hills we now share. The settlers that attempted to carve out a life amid the forests and streams did so at a peril to their own lives and to the lives of their families. The women and children who accompanied their husbands and fathers into the wilderness knew no more safety than did the men. The suffering of the frontier was a suffering shared by both genders.

We are often told of the harshness and dangers of pioneer life. Such stories, however, are mostly associated with the American West, covered wagons, men and the pursuit of our Manifest Destiny. While it may be difficult for those of us who make the Catskills our home today to

contemplate that the ordeal of Mrs. Coleman took place not far from the comfort of our twenty-first-century homes, it is an important part of Catskill Mountain history that we need to awaken to. That men and women struggled together, as the Colemans did, remains an integral part of our shared heritage. That the Indians who once dwelled and hunted here sought only to preserve what they knew to be theirs must also not be removed from the equation. Each struggled here, natives and settlers alike. And in the middle of that struggle were women such as Mrs. Coleman—women who worked hard, knew pain and, at times, labored mightily to simply survive.

Author's note: James Quinlan's original telling of this story appears in the History of Sullivan County, *Liberty, NY: G.M. Beebe and W.T. Morgans, 1873. For additional information on Native Americans and the Catskills, I would also recommend,* Evan T. Pritchard's Native New Yorkers, *San Francisco, CA, and Tulsa, OK: Council Oak Books, 2007.*

Chapter 9
Lucy Lobdell
Female Hunter

The Female Hunter of Long Eddy
The Strange Life-History of Lucy Slater—Her Career
As A Huntress, A Pauper, A Minister, and a
Vagrant—Dressed In Man's Clothing She Wins A Girl's Love
—New York Times, *October 7, 1879*

To readers of the *New York Times* on the morning of October 7, the above headline no doubt did its job capturing their attention, especially in 1879. Most of it is true, of course, except for the part about being a "minister," although in her mind, Lucy (Lobdell) Slater certainly was at one point. Slater was her married name. But George Slater, an angry and jealous husband, had deserted her twenty-seven years earlier only weeks after the birth of their only child; following a return to her parents' home, Lucy Slater was, once again, Lucy Lobdell—at least for a while. She was indeed a hunter, perhaps one of the best in the Catskills at the time. It is true she was a vagrant at times. It is also true she dressed in men's clothing at times. She did win a girl's love—in fact, she won the love of two women. A "strange life-history?" Perhaps. But does that mean Lucy Lobdell was strange? Or is the description offered by the *Times* only apt when applied within the

context of an era and by those who would willingly submit judgment on her life and lifestyle?

Lucy Ann Lobdell was born in Albany County on December 2, 1829, to James and Sarah Lobdell. Her father, mentioned as a lumberman but physically not a well man, moved the family to Delaware County near the border with Sullivan County when Lucy was little. There, as a child, with a disabled father relying on her, Lucy Lobdell took on responsibilities not normally expected of someone of such a young age.

In a narrative of her life, written in 1855, she notes that she "had the charge of some hundred chickens, turkeys, and geese, that I used to raise and sell, and then I had half the money I made in that business and in tending the dairy…In consequence of my keeping poultry, I learned to shoot the hawk, the weasel, the mink, and even down to the rat."

As her writing indicates, Lucy Lobdell was certainly not uneducated and, in fact, would work for a short time as a school teacher during her marriage to George Slater. In an account of meeting the "female hunter" in the woods one day—and later, her family—a peddler by the name of Talmadge wrote, "The whole family were intelligent, well-educated, and communicative." Talmadge also spoke to the fact that she possessed considerable musical talent as well. "After chatting some time, she brought a violin from the closet, and played fifteen or twenty tunes, and also sang a few songs, accompanying herself on the violin in a style that showed she was far from destitute of musical skill."

Lobdell would later recall, as part of her educational experience at the age of fourteen,

> *(I) possessed a temperament which made me foremost on mischief as well as in study. My delight in each was about equal…I would frequently contrive, during the hours of study, to read from another book, which I would conceal from the teacher's eye, and still have my lesson more perfect than half the scholars who were more studious, but less vivacious.*

As the young Lucy became the teenage Lucy, local boys began to take notice. Her first love was a young man by the name of William Smith, a relationship with which her father was not too pleased. Having instructed her to forget Mr. Smith, a defiant young Lucy and William decided

to circumvent her father's wishes and carry on a secret letter-writing "affair." Unfortunately, for both Lucy and William, their letters were soon discovered and, as Lobdell recalls, "all our sorrows and complaints became known." Not terribly crushed, however, she adds, "I got sick of the idea of loving Mr. Smith." Even after Smith proposed marriage, she held her ground, indicating she was too young to wed and that she "was not [her] own mistress yet."

While there is mention of another man in her life at about the same time she was trying to extricate herself from William Smith, it was not much later that George Slater entered her life. What Lucy felt for Slater is difficult to say. Here, too, it appears that her father inserted his will, and after a short relationship, she attempted to rid herself of Mr. Slater as well. Still, Slater persisted, becoming deeply agitated to the point that Lucy became concerned for his mental state. So it was, more out of concern for his health than love that she continued to meet with him. At one point in their relationship, however, it does appear that Lucy undertook a serious effort to discontinue their "romance." Attempting to force a physical separation, she orchestrated a move to her aunt's home in Coxsackie, New York, a move financed by money she had made raising calves. Unfortunately for Lucy, her stay in Coxsackie was brief, and within a short period of time, she was back in her family's home in Delaware County. Upon her return, Slater continued to press. Eventually, despite telling her father that in her heart she "had no joy" for Slater and that her "early love was no more," she would agree to marry him, ultimately feeling that he was "a good workman and an innocent boy." Perhaps the first clue that this would not be a match made in heaven came when Slater, though professing money was owed him, did not have the five dollars to pay for the marriage fee.

And yet, married they were. In a psychiatric report written somewhere between 1880 and 1882, when Lobdell was a patient at the Willard Asylum for the Insane, the assistant physician at the institution noted that during this period in Lucy's life she

> had an aversion to attentions from young men and sought the society of her own sex. It was after the earnest solicitation of her parents and friends that she consented to marry, in her twentieth year, a man for

whom, she has repeatedly stated, she had no affection and from whom she never derived a moment's pleasure, although she endeavored to be a dutiful wife.

Whether this was an accurate accounting of those years in Lucy's life, or Lucy reflecting after the fact, is difficult to say. The fact is she did "endeavor to be a dutiful wife." Yet there was little she could do when it came to the jealousies of George Slater.

Accusations from her husband came repeatedly as Slater falsely accused her of directing her attentions to other men, "waiting" on them, and going on "sprees." Even with the birth of their daughter, little changed. Slater would leave and then return, offering to reconcile. Ultimately summoning the courage required of one who understood the difficulties she would face as a single mother left to provide for a daughter, she sent Slater away and vowed that though he may see his daughter, he would never see her again.

Along with the considerable problems caused by George Slater, times were indeed hard for Lobdell and her family. Support for her disabled father and her mother taxed Lucy's day from before dawn 'till late in the evening. In his account of his chance meeting in the woods with Lucy, Talmadge the peddler penned the following, which Lucy included in her autobiography:

Being well pleased with the idea of having company through the woods, I turned round and said, "Good afternoon, sir." "Good afternoon," replied my new acquaintance, but in a tone of voice that sounded rather peculiar. My suspicions were at once aroused, and to satisfy myself, I made some inquiries in regard to hunting, which were readily answered by the young lady whom I had thus encountered.

 Wishing to witness her skill with her hunting instruments, I commenced bantering her in regard to shooting. She smiled and said she was as good a shot as was in the woods, and to convince me, took out her hunting-knife, and cut a rung, about four inches in diameter, on a tree, with a small spot in the centre; then stepping back thirty yards, and drawing up one of her pistols, put both balls inside the ring. She then, at eighteen rods from the tree, fired a ball from her rifle into the very

*centre. We shortly came to her father's house, and I gladly accepted of
an invitation to stop there over night.*

*The maiden-hunter instead of setting down to rest as most hunters
do when they got home, remarked that she had got chores to do. So,
out she went, and fed, watered, and stabled a pair of young horses, a
yoke of oxen, and three cows. She then went over to the saw-mill, and
brought a slab on her shoulder, that I should not like to have carried, and
with an axe and saw, she soon worked it up into stove-wood. Her next
business was to change her dress, and get tea, which she did in a manner
which would have been creditable to a more scientific cook. After tea, she
finished up the usual house-work, and she commenced playing her needle
in the most lady-like manner. I ascertained that her mother was quite
feeble and her father confined to the house with rheumatism.*

At some point, it became apparent to Lucy that she might be able to
best support her family, including her infant daughter, were she to leave
the family home and seek work elsewhere. Her decision on a course of
action would ultimately begin to redirect her life while, at the same time,
have her questioning the balance of the world she viewed.

*First, my father was lame and in consequence, I had worked in-doors
and out; and as hard times were crowding upon us, I made up my mind
to dress in men's attire to seek labor, as I was used to men's work. And
as I might worker harder at house-work, and get only a dollar per week,
and I was capable of doing's men's work and getting men's wages, I
resolved to try.*

Thus arises the notion, in Lucy's mind, of equal pay for equal work.
Amplifying on her reasoning, Lucy's sense of righteousness begins to
pour forth in her own *Narrative of Lucy Ann Lobdell*:

*I have no home of my own; but it is true I have a father's house, and
could be permitted to stay there, and, at the same time, I should be obliged
to toil from morning till night, and then I could demand but a dollar a
week; and how much, I ask, would this do to support a child and myself.
I tell you, ladies and gentlemen, woman has taken upon herself the curse*

that was laid on father Adam and mother Eve; for by the sweat of her brow does she eat her bread, and in sorrow does she bring forth children. Again, woman is the weaker vessel, and she toils from morning till night.

And, now, I ask, if a man can do a woman's work any quicker or better than a woman herself; or could he collect his thoughts sufficiently to say his prayers with a clear idea? No; if he was confused and housed up with children all day, he would not hesitate to take the burden off his children's shoulders, and allow woman's wages to be on an equality with those of the man. Is there one, indeed, who can look upon that little daughter, and feel that she soon will grow up to toil for the unequal sum allotted to compensate for her toil. I feel I can not submit to see all the bondage with which some woman is oppressed, and listen to the voice of fashion, and repose upon the bosom of death. I can not be reconciled to die, and feel my poor babe will be obliged to toil and feel the wrongs that are unjustly heaped upon her.

Help, one and all, to aid woman, the weaker vessel. If she is willing to toil, give her wages equal to that of man. And as in sorrow she bears her own curse, (nay, indeed, she helps to bear a man's burden also,) secure to her rights, or permit her to wear pants, and breathe the pure air of heaven, and you stay and be convinced at home with the children how pleasant a task is to act the part that woman must act. I suppose that you will laugh at the idea of such a manner of convincing; but I suppose it will not do to convince the man of feeling, who can see and pity, and lend a helping hand to release the afflicted, the child of your bosom, the choice of your heart, young man.

With the above questions receiving no answer, Lucy left her parents' home and her young daughter behind. For a number of years, she wandered the Catskills, making her way through the counties of Delaware, Ulster, Sullivan and eventually down the Delaware River and into Pennsylvania. Living in the woods, where she erected crude structures for shelter, she seldom encountered civilization, with the exception of fulfilling her needs for ammunition and basic supplies. In writing of her life in the wilderness, while offering that she shot "168 deer, a panther, 77 bears, and a number of foxes and wildcats," the *New York Times* noted, "Her wild life was one of thrilling adventures and privation, and it was

Lucy Lobdell. *Image courtesy the Fletcher Davidson Library Archives, Delaware County Historical Association.*

not until she was broken down by the exposure and the hardships of it that she returned to the haunts of civilization."

At some point during her years in the woods, two events occurred that are important to consider. It appears that Lucy would periodically return to her father and mother's home in Delaware County. It was during one of these trips that her parents let it be known that they could no longer care for the daughter she had left behind. With little recourse, Lucy took the four-year-old child from the home of her grandparents and placed her in the poorhouse in Delhi, New York.

During her time "in the woods," it is also clear that somehow and in some way Lucy traveled as far west as Minnesota and spent about two

years there. Traveling in men's clothing and, for at least some of the journey, calling herself La-Roi Lobdell, it appears Lucy "financed" her way west by offering music lessons along the way. When in Minnesota, she supported herself by sitting claims, one a private claim, the other for Kandiyohi Township. In both instances, she became quite friendly with a male counterpart with whom she hunted, talked and—with at least one—shared sleeping quarters. At the time, neither of the two men ever surmised they were in the company of a woman.

In 1858, however, La-Roi's secret was exposed, and a county attorney in Minnesota filed charges against Lucy, alleging, according to an excerpt from *A Random Historical Sketch of Meeker County Minnesota, 1877*, that "one Lobdell, being a women, falsely personates a man, to the great scandal of the community and against the peace and dignity of the State of Minnesota."

As any student of history knows, American justice can move in strange and interesting ways. After hearing evidence, the court ruled in Lucy's favor, noting that it was not illegal for women to "wear the pants," and that basically it was not a right that should be overturned lightly, considering the longevity of the practice.

Unfortunately, the charges brought against Lucy, despite her vindication in court, had predictable consequences when it came to how she was viewed by the community, "subjecting her to insult from the vicious." Distraught and without any means of support, she asked to be returned home to her family. Indigent as she was, it fell to Meeker County to cover the expense of sending her back to New York, thus bringing an end to La-Roi Lobdell's "stay" in Minnesota.

Back home, as she worked to regain her health, she put away men's clothing for a short time in favor of dresses, as she assumed a number of domestic chores. It was not long, however, before she was off again, and shortly after Lucy Lobdell left Delaware County, a man by the name of Joseph Lobdell opened a music school in Warren County, Pennsylvania. It was primarily a singing school. And though the newcomer found work playing music at various functions, it was his singing classes that attracted the attention of local residents, especially female residents. So it was, during the course of the lessons offered, one of the young students took a liking to her teacher and, within a short time, a leading citizen from the area was announcing the engagement of his daughter to Joseph

Lobdell. As is reported in various accounts of the story, however, Lucy's true identity was discovered on the evening prior to the planned nuptial. It is not difficult to imagine what happened next. The scandal shattered the small town and left the young women in a state of devastation and embarrassment. It also placed Lucy's life in imminent danger as, according to the *Sun* of October 18, 1880, "A party of young men determined to tar and feather her and ride her on a rail." Warned of the danger that might confront her, the *Sun* continued, she "fled from the village making her way to Delaware County, N.Y. As it was plain that she was gradually becoming insane, she was finally taken in charge by the poor authorities and placed in the almshouse near Delhi." It was during the course of her stay in the poorhouse that the next, and in many respects final, chapter of Lucy's remarkable life began.

In the spring of 1868, a young woman without money stepped down from a train in New York's Sullivan County. She told the authorities that she was in pursuit of her runaway husband who she had recently married despite the wishes of her parents. Without the funds to continue her pursuit and refusing return to the home of her family in Massachusetts, the young woman who, depending on the source, went by the name of Ada Perry or Marie Louise Perry, was brought to the poorhouse in Delhi where Lucy still resided. Though described by the *New York Herald Tribune* in an August 25, 1871 story as being "about 17 years of age" and "very handsome," she arrived in Delhi in ill health. Once admitted, she was befriended by Lucy, who undertook the task of nursing her back to health. During this period, as the young woman's strength returned, the *Herald Tribune* wrote, "a singular attachment arose" between the two, and after about "a year and a half, the two disappeared one night."

For the next couple of years, the two traveled the landscapes Lucy had come to know. Wandering south from Delhi, they arrived in Monroe County, Pennsylvania. Sleeping wherever they could find shelter—in barns, caves and deserted cabins—they existed on what they could take from the land and on the charity of those they encountered. By this time, Lucy had again donned men's clothing appearing, according to the *Herald Tribune*, "tall and gaunt" and at times acting "insane." She returned to using the name of Joseph, but she added Israel as a middle name and, announcing he was a "prophet," would deliver, noted the *New York Times*, "meaningless

harangues on religious subjects." Insisting they were a "couple," the two would draw further attention to their unique situation by appearing, as the *Times* also noted, "at these settlements leading a bear which they had tamed." Eventually, considering them a "public nuisance," local authorities stepped in, arrested the two and placed them in the Stroudsburg jail where, according to the *Herald Tribune*, "suspicious circumstances led authorities to believe that Joseph Israel Lobdell was not a man, and investigation proved that he was of the other sex, and had successfully concealed the fact for nearly four years." Also learning that the two were paupers who had fled the poorhouse in Delhi, New York, some years earlier, a familiar chain of events began to unfold as both Lobdell and Perry were returned to Delaware County and the poorhouse where they first met.

The couple would stay in Delhi for a period of time before heading back to Pennsylvania. Once again, living in a cave, they took their food from the land in the form of game and berries, as Lucy resumed her identity as Joseph I. Lobdell, offering "sermons" in nearby villages. It was, during one of those sermons, that Lucy was again arrested and placed, this time, in the Wayne County jail. With Lucy behind bars, the ever-faithful Perry did what she could to obtain the release of her "husband." Most accounts of the story indicate that she eventually wrote a petition pleading for Lucy's release. It was a document, as critiqued by the *New York Times*, that was "remarkable" and "was couched in language which was a model of clear and correct English and was powerful in its argument. It was written with a pen made from a split stick, the ink being from the juice of poke-berries."

It is also during her stay in the Wayne County jail that we find one of the few firsthand descriptions of Lucy as she existed at this point in her life. As presented in the September 5, 1871 edition of the *Stamford Mirror* under the heading "The Female Hunter of Long Eddy a Raving Maniac," we learn:

> *She is about medium size, with short shaggy hair, and features in the main repulsive, but bearing traces of lost attractiveness. She had torn every stitch of her clothing off her, and was wrapped in a blanket. Her bed was also torn to pieces and she sleeps in the straw. At times she utters the most unearthly shrieks, and performs the craziest antics*

imaginable. Looking at her now, one would never take her for one of the gentle sex; much less would one think that she was once a handsome girl, sought after for a wife by many worthy men; or that she was once a wife and mother.

For whatever the reason, whether it was the effectiveness of Perry's petition or other circumstances, Lucy was released from the local jail. This time, there would be no return to the Delhi poorhouse. Rather, the couple took up residence in Pennsylvania's Damascus Township in 1877. Here, the record of Lucy's life grows thin, offering in fact differing scenarios regarding her fate. The *New York Times* article falsely concludes that Lucy Lobdell, after working a small farm in Damascus Township for a brief period of time, died at the age of fifty. A careful following of the record, however, indicates that Lucy was anything but dead. It is unclear why the *Times* would produce such a report, though it has been suggested that the information was supplied to the paper in an effort to deflect further inquiry into Lucy's "strange" behavior. In yet another version of Lucy's "death," it was reported by the *Sun* that, after living on the farm in Damascus Township for a period of time, Lucy simply disappeared. Not long after, as the *Sun* offered, "The remains of an unknown person were found in the woods of Sullivan County, not far from the farm, some months afterward. They were believed to be those of the missing 'female hunter,' and were buried as such."

As the story goes on to conclude, however, it could not have been Lucy Lobdell they buried, as "a few weeks ago acquaintances of Lucy Ann Slater were astonished to see her put in an appearance near Long Eddy. She was dressed in a tattered suit of men's clothes and was hopelessly insane."

Following Lucy's surprising "appearance," there would be no return to the small farm she left behind or the almshouse in Delhi. Instead, Lucy became a patient at the Willard Asylum for the Insane in 1880. Located in the town of Ovid in New York's Seneca County, the Willard Asylum at the time of Lucy's admittance was the largest such institution in the United States, housing some 1,500 patients. Psychiatric records relating to Lucy's condition exist in the notes of Dr. P.M. Wise who, as noted earlier, served as the assistant physician at Willard Asylum and are contained within an article written in 1883 for the *Alienist and Neurologist:*

A Quarterly Journal of Scientific, Clinical and Forensic Psychiatry and Neurology 4, no.1, under the title of a "Case of Sexual Perversion." According to the review presented, Dr. Wise ultimately arrives at the conclusion that:

> *During the two years she has been under observation in the Willard Asylum she has had repeated paroxysmal attacks of erotomania and exhilaration, without periodicity, followed by corresponding periods of mental and physical depression. Dementia has been progressive and she is fast losing her memory and capacity for coherent discourse.*

It is believed that Lucy Lobdell spent the remainder of her years within the confines of the asylum at Ovid, dying there in 1889 at the age of sixty.

As for those who were part of her life, indications are that Lucy's "wife" remained on the small farm in Pennsylvania. Lucy's parents were dead and little was ever heard again of George Slater. There are, however, numerous citations regarding the daughter Lucy had with Slater so many years before. Eventually adopted by a Wayne County, Pennsylvania couple named Fortman, the young girl seemed unable to escape experiencing the same difficulties with men her mother had known as a young woman—actually, worse.

The *New York Herald Tribune*, regarding the daughter, reported:

> *On the 16th of July last, she was forcibly abducted from Mr. Fortman's by a gang of fiends, and, after being chloroformed, was thrown into the Delaware River to drown. She was rescued, however, by a farmer living near, but she again disappeared and was not found for four days. She had lost her mind by the fearful events of the night through which she had passed, and had been wandering through the woods all that time. The cause of her attempted murder was her repeated rejection of degrading proposals made to her by Thomas Keats, and a suit having been commenced against him for slander and threats made against the girl, in which she was to be principal witness, he had her abducted and thrown into the river. At least strong suspicions exist against him, and he is now in jail at Honesdale, Penn., awaiting trial. The girl has not yet recovered entirely from the shock and the consequences of her wanderings.*

Perhaps, if the *New York Times* headline that began this story had carried the word "sad" rather than "strange," it would have offered a more apt description. In many respects, this is the story of two Lucy Lobdells, two stories that diverge at a certain point in time as the female hunter transforms into Joseph Lobdell. The sadness that is evident imbeds itself in the knowledge that the "voice" a young Lucy found in her *Narrative*—as she spoke of life as a mother and of her desire for basic equality—was usurped by a voice clouded in mental illness, an illness accentuated by a world that could not comprehend its lack of understanding or its inability to effectively deal with "difference."

In many ways, it is the words of a young Lucy that offers us, 150 years later, a look back at a departure point from where America began a journey, traveling a road where basic perceptions, biases and even the law would be challenged. Yet within the thoughts of a young mother, thoughts crafted in a rural Catskill Mountain outpost, Lucy Lobdell's earlier plea still stands without complete answer. It is a plea that continues to challenge us across the ages:

> *Is there one, indeed, who can look upon that little daughter, and feel that she soon will grow up to toil for the unequal sum allotted to compensate for her toil. I feel I can not submit to see all the bondage with which some woman is oppressed, and listen to the voice of fashion, and repose upon the bosom of death. I can not be reconciled to die, and feel my poor babe will be obliged to toil and feel the wrongs that are unjustly heaped upon her.*

Author's note: The life and times of Lucy Lobdell is a difficult story to reconstruct. Through the various newspaper articles cited in the text, Lobdell's own Narrative of Lucy Ann Lobdell *and other sources, this story attempts to present as accurate an accounting as possible. I am indebted to the Delaware County Historical Association and the Fletcher Davidson Library Archives for their efforts to preserve the story of Lucy Lobdell and their assistance in making her* Narrative *and other materials available. For more on the remarkable life of Lucy Lobdell, I would encourage the reader to visit http://www.oneonta.edu/library/dailylife/family/lucy.html. The report from Dr. P.M. Wise can also be found in* Gay American History: Lesbians and Gay Men in the U.S.A., *New York: Penguin, 1992, by Jonathan Ned Katz.*

Chapter 10

The Tale of the Forty-Five-Cent Wife

It was in the fall of 1892 that a young woman named Phaley married a man named Thompson and took up residence with him and his father on their property near West Hurley, New York. In June of the following year, however, though the source of the problem has since been lost, something Phaley did greatly displeased her new husband. When the husband spoke of the matter to a friend named Lewis a short while later, Lewis, sensing Thompson's dissatisfaction with his wife, offered to buy her. Adjourning to a local inn, Lewis and Thompson, over a drink of hard cider, agreed on a deal and the purchase price of forty-five cents.

Upon his return home, Thompson informed his wife of the arrangement he had struck. As the story is told, young Phaley is said to have had no objection to her husband's entrepreneurial efforts and, in fact, was quite pleased with the transaction. So it was the very next day that Thompson delivered his wife to Lewis at his home in Sawkill.

Over the next few days, however, the newly minted bachelor appears to have had second thoughts. Returning to the Lewis home the following Saturday, Thompson attempted to persuade Phaley to return. She refused. In fact, not only was the young Phaley quite content with the new arrangement, but she also took to scolding her "former" husband

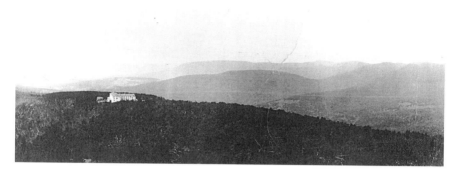

View from the top of Overlook Mountain. *Photo courtesy of the Historical Society of Woodstock.*

for attempting to back out of a deal. "You got your forty-five cents and I ain't going back!" was her final response to his pleas.

Arriving home, Thompson informed his father what had happened and that Phaley would not be returning. Traveling to Kingston a short time later, the father was seen in search of a lawyer, hoping to compel Phaley's return by force of law.

Chapter II
Days in the Life
The Diary of Eliza Ogden Mead

As with many of the women in this book, the life of Eliza Mead has never drawn the attention of historians. Rather, hers was the life of a daughter, wife and mother who rose every day in Walton, New York, to tend to the duties and the responsibilities commiserate with a women's place in nineteenth-century America. Mead's diary, as found in the archives of the Delaware County Historical Society, is voluminous. With its almost daily entries, the diary covers the years from 1853 to 1869. Yet, as the nation moved into the Civil War and the years of Reconstruction, her reflections on the world are remarkably centered on the day-to-day life of a woman maintaining and sustaining her family and home within the remote geography of the Catskill Mountains. Like those who both preceded and followed her, the words penned by Mead offer testament to the purposeful lives women throughout the Catskills crafted, not in subservient support of anything or anyone but as equal partners in the struggle—and joys—of building a Catskill Mountain life.

Eliza Mead was born Eliza Ogden in 1812. A child of Walton, daughter of Daniel Ogden, Eliza was the youngest of eleven children. In 1837, she married Gabriel Mead and, in 1842, gave birth to their only child, George. Of Eliza's siblings, James would eventually live with his sister and Gabriel, while another brother, Thomas, served as a physician

in Walton. Gabriel Mead was the son of Alan Mead, an early settler in Walton who made tanning the family business.

As noted, Eliza Mead's diary covers a substantial number of years. For the purposes of this text, and in an effort to portray the intricacies of daily life in the Catskills during the 1800s, the dates that have been excerpted here are all from 1853, the first year Eliza placed ink on paper. Within her diary, the reader finds not only a glimpse into small-town Catskill Mountain life but also a unique look at the labors each day demanded, the comings and goings of family members, neighbors and friends, the ever-present influence of the weather and a glimpse at mid-1800s medicine, as Eliza, suffering from an unknown illness late in 1853, takes to "indulging" in a cure promised by the waters of a sulfur spring. All spellings, punctuations and structure have been left as found in the transcript of the diary.

January

Tues. 11th *Clear a little while but it clouded up this afternoon and is snowing at bedtime but not very fast. pealed and stewed two pumpkins that Roswell brought up yesterday. killed a chicken and cooked it for dinner. churned and mended the wollen clothes. have been down to Mary's this afternoon and evening. Gabriel and George came down to tea. they have got a new melodeon with a piano frame it is a very pretty piece of furniture. the girls play a little. but they have not had it long yet. we are all going over to stay at Roswells tonight.*

Wed. 12th *We got up and come home from Roswells about six o'clock. found the snow two or three inches deep and it has been snowing all day the storm came from the northeast. it is so fine and comes so moderate that it does not gain very fast. I baked Caroline an apple pie carried it over and staid there this forenoon. she is quite comfortable most of the time and thinks she gains some strength. but I don't think she really is any better or ever will be. ironed and done the mending this afternoon. I expect to go over and stay at Carolines again to night do not have to set up but go for company as there is nobody there but Roswell and Esther. George has gone to speaking school this evening and Gabriel will stay here to-night alone.*

March

Wed. 9th *This has been a dark rain day the wind turned to the west just at dark and it is blowing pretty cold now but the storm has eased. baked bread and churned. have not much to do now days but knit. the Doctor has given me a wash for this humer in my face and it makes me look pretty much like an Indian. Gabriel and Roswell have both been out this evening and George and I have spent it alone playing dominoes.*

Thurs. 10th *Clear and pleasant. the sleighing is about gone and people travel mostly in wagons. Marcus Mason called here this afternoon. he has come to town to attend his sister Louise's funeral. she died in Owego last Tuesday was brought here yesterday and the funeral was attended in the Presbyterian church this afternoon at two o'clock. Mr. Pattengill preached the sermon and she was buried in the new burying ground over the river. Gabriel went to the funeral I did not go because my face looked so bad. Mr. and Mrs. Ress have spent the evening here. George went over and staid with their boys while they were here. I wrote a letter to Frances Clark this afternoon and sent it to the post office this evening.*

Mon. 14th *A real cold blustering day and is freezing hard to night. washed and churned. got my clothes dry and into the house. patched the lounge and done some other mending. Gabriel was called off a jury before noon and did not get home till dark. Marcus Mason stayed with us last night. started for the railroad this morning. he is baggage master on the express train. Adeline Brisack and Betsy Ogden here after milk this afternoon. sent eight dozen eggs to Hancock to day by James. he has gone down with a load of leather.*

Tues. 15th *Another severe cold day nearly as cold as any we have had this winter. the wind has gone down to night and it is clear and freezing cold. baked bread burnt coffee and stewed apples. four calls for milk and buttermilk to day. James got only 13 cents a dozen for the eggs that I sent to Hancock by him.*

April

Tues. 5th *Got up this morning and found the ground covered with snow. and it has blowed hard and snowed some. but there is not much on the*

ground now as there was this morning. I packed a part of our hams and dried beef in ashes this morning and put them away. am going to try an experiment and see if we can keep them any better than we have formerly. Matilda sent over this morning for me to go down to William Norths with her and spend the day. so I fixed some grub for Gabriel and Roswell and went had a good visit. and plenty of warm sugar Henry carried us down and Gabriel came after us. Ellen Johnson and her little brother were there spending the day. Charlotte and Johnny and Williams two little ones made lively times. I have mended the wollen clothes this evening since I got home.

Thurs. 7th Clear and pleasant churned. rinsed up the clothes and got them dry and ironed this afternoon done the mending and commenced knitting up a streaked mitten for George. Samuel Fitch here to work laying a cellar wall. Gabriel and James have been to the village this evening. Charlotte and Henry came over just at dark and I gave each of them a hen. they are getting a flock together

Tues. 26th Cloudy early in the morning but cleared off before noon and is very pleasant now. washed and churned. spread the clothes on the grass. finished the carpet this afternoon and covered a ball for George. brought in the wollen clothes mended and put them away. went over to Mr Crawleys just at dark to see when Ann Eliza was coming to sew for me she was to have come last week but her sister Mrs. Dutcher is at home and she don't know as she can come in two or three weeks. saw some daffodils in blossom at Mr Crawleys. Matilda has some very handsome cactus in blossom in the house. Charley Townsend has come to stay with George to night.

Thurs. 29th Another clear and pleasant day. baked bread rinsed up the clothes got them dry and ironed this afternoon. Aunt Lucy came up this morning and spent the day. she brought up a ball of yarn to twist on my wheel. Abram came over here this morning and brought twelve pounds of maple sugar and a bag of husks to fill up my beds with. Father made us quite a call this afternoon is complaining some of a lame back and arms.

June

Fri. 17th *We had a nice shower this forenoon and it is a little cooler to night but does not look quite like settled weather yet. Finished a pair of pantaloons for James and finished a white sun bonnet that Phebe commenced before she went away. Malona and Hen here to day making mortar for the new building. After tea I went St John and Norths and bought a yard of linen for shirt bosoms. Two dozen shirt buttons a pound of castile soap and a yard of muslin to make a sunbonnet of. made Fanny quite a long call on my way home.*

Mon. 20th *It looked like rain this morning but finally cleared off and has been very warm. washed and got clothes out dry. James has mowed the door yard. have quite a family of masons. Malona and Hen have been here since last friday and this morning Mr. Pierson came and commenced plastering the new building up stairs the carpenters have got nearly through. heard to day of the death of Catherine Hess and Edwin Guilds little boy. Catherine is to be buried to-morrow. Jane has been over here to get Betsy to keep house for her while she goes to the funeral. I called down to John Townsends a little while just at night. Mr. and Mrs. Howell are there spending a few weeks. called at Edwin Hoyts on my way home. George has gone to stay all night Charley Townsend. Betsy has gone to bed with a tooth ache and Gabriel James and Roswell have gone to the village to see a black yankee doodle.*

Wed. 22nd *This has been the warmest day I ever experienced. James and I went out this morning and picked strawberries all the forenoon. we picked them on the stem and filled a half bushel basket. it has taken us all the afternoon to hull them. had ten pounds besides enough for tea.*

July

Wed. 20th *Clear most of the time with a few clouds occasionally. ironed till between ten and eleven then put on my raspberry rig and picked berries till between three and four. Phebe and Julietta went to spend the day with Cousin Mary but she was engaged so they called up to Mr. Thomas's then came back to their Uncle Thomas's and spent the*

For most women, tending the family garden was a required part of daily life in the Catskills. *Photo courtesy of Frederick Allen.*

day. Betsy came up after dinner and helped pick berries. we got about ten quarts. I have put seven pounds with sugar and shall preserve them in the morning. I called around the village in night to pick up a load to go whortleberrying to-morrow afternoon. Roswell talks of taking the bark wagon and taking a load up to Mount Holly.*

August

Thurs. 18th *The sun shown a very little in the middle of the day. We had a very hard shower between eight and nine this morning. the lightning struck Mr. Fanchers store tore the awning down in front of it. tore off part of the roof and some of the siding and broke the windows very much. Mr Fancher was standing under the awning when it was struck was badly stunned so that he was bewildered awhile but did not last long and he was able to walk home with help. Henry Meal was in front of the store but was not much injured it was a very providential*

escape. at the same time there was another bolt struck Seymour St Johns lighting rod and tore a hole in the ground as big as my arm and two feet deep. Gabriel was standing on the store steps at the time and it made him sick and faint for a moment. when Mr. Fanchers store was struck there was a cloud of yellow looking dust and smoke and I thought some building was on fire and was afraid it was Fathers so I went down as quick as I could and learned where and what it was and felt very thankful that things were no worse. made some pies before breakfast. as soon as we were through with breakfast George and I started after some berries. we got about three quarts and then the shower drove us off. Julietta has got two more dresses finished and hung away. I have been sewing some edging on some lace collars that Phebe has been making each of us one. they are very pretty. Phebe made me a present of a crimson crape shawl to day.

October

Thurs. 6th A cold rain awhile in the morning and the wind has blowed a hurricane all day. had not any big work went over to Johns and helped Matilda divide a pound of black thread and half a pound of silk that John got while he was in New York. I have finished the skirt of my dress. and sewed the hooks and eyes on for the waist and now shall have to let it wait till I can get some help to fit it. Betsy has finished my petticoat. she has been over to Jane Crandalls to meeting this evening and the gentlemen have all been to the store so that I have spent the evening pretty much alone. finished reading Isaac I. Hopper like the last part better than the first. I have commenced another book called Social life in Germany by Charles Loring Brace.

Fri. 14th A clear cold day. Gabriel and I started this morning about eight o'clock for Richfield Springs. took the new road to Franklin from there to Otego and up the river to Shepherds Plains when we took dinner at Hathaways and not much to brag of either. came on to Oneonta and Gabriel stopped and bought a boot tree then we came on here to Milford where we put up for the night. it was after dark when we got here and I have not learned the name of the house. got supper and am about tired enough to go to bed. Sweet is the name of the hotel.

Sat. 15th *Another clear cold day got started this morning about eight o'clock came on to Cooperstown and stopped long enough for Gabriel to do some trading rode around the village some the Cooper place is the elephant of the place and a beautiful summer residence. took the plank road to Springfield stopped at and got dinner it on the bank of Otsego Lake a very pleasant place and they gave us an excellent dinner. came on to Hallsville turned to the left and soon came on to the Cherry valley and fort plains turnpike which led us here the Richfield Springs. got here about four o'clock and put up at the Spring house kept by Joshua Whitney. they have some eight or ten boarders but it is past the season for the crowd and boarding houses are mostly closed. Gabriel and I have been out this evening to consult a physician and find a private boarding house the physician was from home and we shall have to wait till morning to see him. called at a Mr Carys and partly engaged board there. they have no family except the man and wife and don't keep any girl in the winter but thought they would let me in to accommodate me as I prefer a private boarding place. the grounds around the Spring are very pleasant but the water is awful however I shall drink it freely if it will be beneficial.*

Sun. 16th *Quite a heavy fog this morning and staid on till nearly ten then cleared away and was warmer than yesterday. got up about seven went to the Spring and drank two tumblers walked about a mile and took breakfast about eight sit awhile after breakfast then called on Doctor Manly. he thinks I am pretty well pepered and that it may take some time to effect a cure but he thinks the springs will benefit me without a doubt. they have three churches in the place but no preaching to day except at the Universalist house. Gabriel went to the Presbyterian house this morning and heard a sermon read have got somewhat acquainted with the folks and house and like it pretty well but think I should prefer going to a private house when Gabriel goes home. he has paid me twenty five dollars and I have packed his things for early start in the morning.*

Mon. 17th *Another clear and beautiful day and delightful moonlight evening. rose about six went to the springs and took two tumblers of*

water took an early breakfast with Gabriel and came up here to Mr Carys with him when he started for home and now I shall have to work out my way alone for a few weeks to come. Miss Whitney came in soon after breakfast to know if Mr Cary was going down to his farm and if he was she wanted a chance to go with him. gave me an invitation and three of her nieces and we got into a lumber wagon with boards across the top and rode seven miles down to Lake Otsego where his farm lies. he stopped to fill his wagon with corn and oats and we went on down to the lake shore. could see nearly the whole length of the lake it was a beautiful view. and we took quite a ramble through the grounds of a summer residence owned by a Mr Clark it is situated at the head of the lake and the shrubbery and ground are beautifully laid out from there we went to a Mr Whites place and gathered chess nuts till Mr Cary came for us to go home. he had filled his wagon with corn and oats. the oats were in bags and we each of us took a bag one right behind the other and started for home followed the plank road to the turnpike and came the same way we did Saturday. we had some funny remarks made about us as we passed along but Mr Cary bore it well and we had a real nice time. got home about two o'clock. found dinner ready and I had a good appetite to eat after first taking a drink of the water. Mrs Cary has a niece here making dresses for her. she rooms with me. two of Doctor Manlys daughters called here this evening.

Tues. 18th Another pleasant day but not quite so clear as yesterday. rather late getting up this morning. went to the springs and took two tumblers of water then walked awhile and took the third. Miss Whitney was there when I went the first time an said she had been up an hour then. the water operates on me as physic and this morning it nauseated me so that I could not eat any breakfast. eat some dinner and had a good appetite for supper. have staid in the house pretty much to day. taken one walk and drank seven tumblers of water. I have been working on a muslin cap that Phebe gave me when I was there last fall. the dress making moves briskly. they have four different ones commenced and one silk about finished. have not seen the Miss Whitney only as I met them at the Springs to day

Wed. 19th *Just as clear as ever it freezes quite hard at night and is cool enough through the day to need a little fire. rose about sunrise went to the spring took two tumblers of water came back to the house and exercised on the piazza about half an hour then went back and took another tumbler. it made me so sick as to vomit once but I got over sooner than yesterday and was ready for breakfast in time. drank two before dinner and two before tea. I have been working on my cap most of the time. done a little stitching for Mr Cary started to call at Mr Whitnys but the young ladies were out riding and I went on an took a walk. Miss Manly called here this afternoon and gave the dress maker an invitation to spend the evening with her. she said she had been making cake ice cream and candy and was going to have some belles*

Across generations, women have remained at the center and at the heart of Catskill Mountain families. *Photo courtesy of Frederick Allen.*

there. Mr Cary has spent the evening up town. Mrs Cary and I have had the house to ourselves.

*Thurs. 20th Just as pleasant as ever and a little warmer have drank the usual quantity of water but have not felt quite so bad from the effects of it as I do some days. have written a letter to Phebe Smith and sent it off. Mr Cary came in this evening and brought me a letter from Gabriel it came rather sooner than I expected but none the less welcome for that he arrived home Tuesday evening found all well and in good order sent me some Post office stamps in the letter. the mantua** makers mother and cousin came after her this morning and she went home with them. will come back sometime next week. I called at Mr. Whitneys this afternoon. the young ladies had gone to Sharon Springs worked on my cap some'*

*Whortleberry: blueberry, also related to huckleberry; native to the eastern half of the United States.
**Mantua: a woman's loose gown worn as a robe or overdress in the early eighteenth century.

Author's note: I am indebted to the assistance of the Delaware County Historical for access to Eliza Mead's diary. Their professionalism, kindnesses and efforts to provide copies of Eliza's entries are greatly appreciated.

Chapter 12

Over My Dead Body (Literally)

Aristotle once offered, "Jealousy is both reasonable and belongs to reasonable men." It is clear that Aristotle never met Genase Burgess.

Burgess, who lived near Middletown Township in Delaware County, died in 1767. For most men, that would be the end of their story. For Burgess, in many respects, it was just the beginning. It seems that during the latter years of his life, Burgess married—as the tale has been handed down—a "young buxom woman." Burgess was terribly and madly in love with his young bride and, at the same time, very jealous should there be even a hint that her affections might wander elsewhere. It was when he contemplated what would happen to her following his death that his "jealousy" was elevated to a higher level.

Fearing that his wife would take up with another man and marry again following his death, Burgess let it be known that, upon his demise, he should be interred beneath the front walkway to his house. His reasoning—if reasoning is the word that can be applied here—was fairly simple: if his young widow walked over his body as she both exited and entered the home each day, she would be reminded of him constantly and, as a result, be less likely to lend her affections to another man.

Unfortunately, for Burgess, his last request was not honored with any degree of exactness. While he was indeed buried on his property, his final

resting place would not be beneath the entrance to his home. Instead, Mr. Burgess was laid to rest in a garden on his property. Further, and even more tragically for his eternal soul, the young wife would remarry and dwell, with her new husband, in the home Burgess had hoped would remain hers—and hers alone.

It is said, in his jealous agony, that the ghost of Genase Burgess can be been seen in the hours before dawn by travelers along the road near the Middletown line.

THE RIGHT TO PROPERTY

Probably the *worst* indignity suffered by the very dead Mr. Burgess wasn't the fact that he ended up in a nonpreferred burial plot, but that, under eighteenth-century law, his home, following the marriage of his former wife to her new husband, became the property of another man. It would not be until 1848 that New York State laws would begin to recognize the right of a married women to control property that was hers prior to marriage. Prior to 1848, women couldn't enter into contracts, sell or dispose of property they owned or have control of their own inheritance

Under the Married Women's Property Act of 1848, a law that would become a model for other states to follow, New York State finally began to recognize the right of women to control what was theirs, regardless of their marital status.

> *AN ACT for the effectual protection of the property of married women: Passed April 7, 1848.*
>
> *The People of the State of New York, represented in Senate and Assembly do enact as follows:*
>
> *Sec. 1. The real and personal property of any female who may hereafter marry, and which she shall own at the time of marriage, and the rents issues and profits thereof shall not be subject to the disposal of her husband, nor be liable for his debts, and shall continue her sole and separate property, as if she were a single female.*

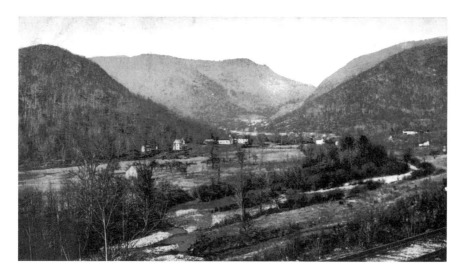

Early 1900s view of the Catskills from Lanesville, New York. *Author's collection.*

Sec. 2. The real and personal property, and the rents issues and profits thereof of any female now married shall not be subject to the disposal of her husband; but shall be her sole and separate property as if she were a single female except so far as the same may be liable for the debts of her husband heretofore contracted.

Sec. 3. It shall be lawful for any married female to receive, by gift, grant devise or bequest, from any person other than her husband and hold to her sole and separate use, as if she were a single female, real and personal property, and the rents, issues and profits thereof, and the same shall not be subject to the disposal of her husband, nor be liable for his debts.

Sec. 4. All contracts made between persons in contemplation of marriage shall remain in full force after such marriage takes place.

Author's note: I found the original telling of the tale involving Mr. Burgess in the Proceedings of the Meeting of the Delaware County Historical Society, Held at Media, December 5, 1901. The Married Women's Property Act of 1848 can be found online in the Library of Congress's American Memory section. http://memory. loc.gov/ammem/index.html.

Chapter 13

Something Better

Agnes Schleicher and the Creation of Tradition

At its heart, this is a story about one woman whose efforts made a difference. It is also a story about community and volunteerism—the same type of volunteerism that women have offered throughout the history of Catskills as mothers, wives and, most importantly, as individuals.

Each year, on Christmas Eve, individuals and families alike flock to the center of Woodstock, New York, to witness and celebrate the arrival of Santa Claus. The question on the minds of those who gather isn't whether Santa Claus will arrive but how he will arrive. In a town where secrets aren't usually secrets for long, Santa's arrival on Woodstock's village green is the one bit of information that no one knows. Each year is unique. Perhaps he will appear on the church steeple and require a ladder truck from the fire department to help bring him down. It is also quite possible he may simply saunter into town on the back of an elephant. Or, as he has, his arrival might be from above, descending from a flying saucer swung into place by a large crane. More fittingly, he just might arrive in a Volkswagen "hippie bus." After all, it is Woodstock.

Over the years, dedicated volunteers have worked in secrecy to plan Christmas Eve on Woodstock's village green. Few remember, however, the one woman who launched this rite of the season. Her name was Agnes Schleicher.

Change comes slowly to small towns in the Catskills, and it comes in various shapes and forms. While a voice such as Marion Bullard's pushed for important and dramatic civic change, quiet voices and deeds are also at work in the many ways

volunteers dedicate their time and skills to their communities. Such was the way of Agnes Schleicher. Each day, along with her husband, she would open her small gift store, the Jack Horner Shoppe, offering delightful European treasures to visitors and townspeople alike. Yet within her also lay a talent for the theater and directing. So it was, at some point in 1932, that Schleicher agreed to take on the design and production of a new event in Woodstock: a Christmas Eve celebration. With her decision to do so, Agnes Schleicher would inaugurate what has become Woodstock's most enduring tradition, a tradition illustrative of the fact that a town's social fabric is woven not by politics or business but by those who return something to their neighbors.

Simplicity, creativity, beauty, precedence. All were hallmarks of the first Christmas Eve celebration held in Woodstock in 1932. For those who gather of late, with the arrival of Santa Claus at the center of the evening, most would be surprised if they transported back almost eight decades to that first celebration—surprised, no doubt, by the quiet calm

The Woodstock Dutch Reform Church in the center of Woodstock, New York (circa 1950). The first Christmas Eve celebration, as directed by Agnes Schleicher, played out on its steps and portico. *Photo courtesy of the Historical Society of Woodstock.*

that pervaded the center of town as bells from the Dutch Reformed Church summoned Woodstockers to the village green at precisely 6:00 p.m. It had been a year where Woodstockers could be forgiven if celebration of the season was not at the forefront of their minds and, most of all, their hearts. The Depression that gripped the nation had also crept quietly through the Catskills. Self-sufficiency, while always a part of the Woodstock character, had been increasingly called upon to stave off the impact of unemployment and little money. While a "New Deal" was promised as a part of their collective future, the past sins of capitalism daunted the individual spirit of the season like a ghost straight from the pen of Dickens—or so it seemed.

As the community gathered in response to the bells, streetlights went dark in the center of town, as is still the custom today. The work and preparation that Agnes Schleicher had single-mindedly invested over the past weeks was about to take form. On cue, a lone beam of light dawned and directed the vision of all toward the front of the Dutch Reformed Church, illuminating its steeple, the stately white pillars and the single star that hung centered between them. The conversations of those gathered fell silent as the words of "The First Noel" rose out of darkness. As they would throughout the evening, the hidden choir's disembodied voices carried on a cold winter's night. The evening's program, as crafted by Schleicher, was underway. It would take the form of a tableau: three scenes in which the nativity would be unveiled by silent actors in costume.

When the choir fell silent, the voice of the Reverend Harvey Todd broke through the evening air, offering passages from Matthew and Luke 2:8–11:

> *And there were shepherds living out in the fields nearby, keeping watch over their flocks at night. An angel of the Lord appeared to them, and the glory of the Lord shone around them, and they were terrified. But the angel said to them, "Do not be afraid. I bring you good news of great joy that will be for all the people. Today in the town of David a Savior has been born to you."*

As the choir introduced the beginning of the tableau with "Adeste Fidelis," angels in "shinning whiteness" appeared at the center of the church portico arranged in the "graduated manner of the pipes of an

organ." Below and to one side of the angels, shepherds followed, as the music transitioned to "While Shepherds Watched Their Flocks." As the angels remained at the center, the three wise men entered at the opposite side of the shepherds, doing so as the choir brought forth "We Three Kings of Orient Are."

Following a pause so those gathered could take in the richness of the scene before them, the choir began "Silent Night." With that, the angels parted, moving slowly toward the interior of the church. As they did, they revealed for the first time the holy family, as Mary and Joseph stood looking down at the Christ child. When "Silent Night" and the simple magic of the moment faded, the shepherds and wise men moved up the steps of the portico toward the child as "Hark the Herald Angels Sing" and "It Came Upon a Midnight Clear" brought the tableau to an end. With that, the spotlight dimmed. The church grew dark, and the crowd's attention was redirected to a sight more familiar to those who, today, make the yearly Christmas Eve pilgrimage to Woodstock: the arrival of Santa Claus.

To put it simply, for a more simple time, Santa arrived not by sitting atop a Woodstock Festival dove or by having been shot out of a cannon from a rooftop. Rather, having waited at Peper's Garage, he made his way slowly up Mill Hill Road by truck, with a pack of gifts square on his back and "shaking his sleigh bells merrily." Taking up position beneath the lighted evergreen on the Village Green, Santa proceeded to distribute gifts to over 150 Woodstock children, many no doubt receiving the only present they would receive since Depression shadowed Christmas. As Santa went about his business, the choir, finally liberated from the darkness, led villagers in the singing of "Good King Wenceslas."

Writing in her *Kingston Daily Freeman* column Sparks, Woodstock writer and artist Marion Bullard would later recall that first Christmas Eve and the impact of Schleicher's effort:

> *The sky that night was a deep vibrant blue and hundreds of stars gleamed through the tall maples in front of the lighted façade of the historic Dutch Reformed Church. The air was still and the new snow was white over the village square...Most of us there found it unforgettable and felt the strength and reality of the beautiful story that has come*

*undimmed down through the centuries. I wondered that night if perhaps
this was the beginning of something better.*

For her work, Agnes Schleicher would receive high praise. The *Catskill
Mountain Star* would report that the evening was "so consistently excellent
as to establish a precedent in local tradition. Miss Schleicher held to a
symbolism that was simple yet tremendously effective." Marion Bullard
furthered singled out Schleicher for giving "the observance a simplicity
and beauty that establish her as a capable director."

Schleicher, however, was also "capably" aided by a number of
Woodstockers that evening as she crafted the essential elements of her
production. The authenticity of the tableau, for example, was enhanced
by the fact that many of the costumes worn by those participating actually
came from the Middle East. As noted by the *Kingston Daily Freeman*, adding
"to the warm beauty of the tableau was the fact that those participating
were dressed in costumes from Persia and Palestine, which were lent
by (children's authors) Maud and Miska Petersham and Mrs. Eric Carl
Lindin." Winifred Haile directed the choir, while Mrs. George Riseley
played the organ. Casting involved the children of the community. Alice
Houst played the part of Mary, with Margaret Ives as Joseph (a uniquely
all-female version of the holy family, as introduced by Schleicher). The
three wise men were Peter Leaycraft, Robert Cantine and Karl Schleicher.
The shepherds assembled were portrayed by Ludwig Baumgarten,
Rudolph Baumgarten, Toshi Ohta, Martin Cantine and Alex Easton,
while Nancy Grimm, Mary Adeline Summers, Mary Clough, Florence
de Ruyter, Louise Shultis, Ruth Shultis and Judith Cohen brought the
angels center stage. The evening was sponsored by the Community
Association and saw "Mr. Houst" directing the lighting (you know you
are in a small town when the local press refers to an individual simply as
"Mr." and the reader knows exactly who is referenced.), while Nino Faggi
and Hans Schleicher handled the spotlight.

Though Agnes Schleicher, long ago, handed over the reins of directing the
celebration, Christmas Eve in Woodstock remains the town's most lasting
tradition. The passing years and the changes Woodstock has seen have done
little to lessen that important fact. Today, though many of the religious
trappings of years past have diminished, a certain critical element remains

Christmas Eve Program
at
The Community
Christmas Tree
on the Village Green

Beginning at 6 P.M. with the ringing of the
church bells.

SONG - The First Noel Everybody

Reading from the Bible Mr. Todd

TABLEAU

 Introductory song: Adeste Fideles Choir

 First Scene
 Song: While Shepherds Watched
 Their Flocks Choir

 Second Scene
 Song: We Three Kings of Orient Are
 Choir

 Third Scene
 Song: Silent Night Choir

SONG - Hark the Herald Angels Sing
 Everybody

SONG - It Came Upon the Midnight Clear
 Everbody

Everybody Invited !

The 1932 program from the first Christmas Eve celebration in Woodstock, New York. *Image courtesy of the Historical Society of Woodstock, Woodstock Library Collection.*

from Schleicher's original vision, most notably the gathering of community. Over the span of almost eight decades, Woodstockers have found their way to the Village Green on that most special of nights. Through times of war, economic turmoil and periods of political and social upheaval, there has been a singular certainty to December 24 in Woodstock.

Certainty in Woodstock? While a cursory survey of Woodstock headlines over the years might make such an observation seem like a paradox, when one digs deeper into Woodstock's history—and you don't have to dig too deep—you find such certainty further expressed in the sense of community that fills the important chapters of Woodstock's story. You will find it in old town documents known as the *Record of the Overseers of the Poor*, as the town sought to support its own throughout the

eighteenth and nineteenth centuries; it's there in the threads of uprising known as the Down Rent War, as settlers banded together to battle the greed of distant landowners; you see it in the coming together of a divided town through two world wars; and you will find it today in the daily work offered by Meals on Wheels, the soup kitchen, volunteer firefighters, ladies auxiliaries and in those who don't need a holiday season to give freely of their time and talents to their neighbors. In short, there *is* a certainty to the Woodstock character, as embedded within the town's unique notion of community. It is a certainty that is found in all small towns throughout the Catskills. Agnes Schleicher may have produced something unique and memorable, but volunteers—women and men alike—offer their own form of service each and every day. It is the essential element in the creation of what we call community.

In her column recalling that first Christmas Eve celebration in Woodstock and the program produced by Schleicher, Marion Bullard went on to wonder whether, drawing on the experience of that night, we might "believe in the fundamental good intentions of our neighbors in the town and, for a little while feel gently, kindly and hopeful. Maybe, from this Christmas Eve, all of us will be able to think more clearly and act more generously, stand together more willingly and surely in the things that matter."

Perhaps there is another certainty to Woodstock's history. Perhaps it's in what many like Schleicher have quietly drawn throughout the years from a cold evening spent on a Village Green toward the end of an old and tired year. Perhaps in Woodstock's own Christmas Eve celebration we find—through the glad tidings of neighbors, the music and the anticipation of Santa's well-secreted plans for arrival—a town's collective reasons for hoping, as Bullard hoped, for "something better." It is a hope that is shared throughout the Catskills by those who, like Agnes Schleicher, give without asking for reward—a role that women know all so well.

Authors note: Articles cited from the Kingston Daily Freeman *and the* Catskill Mountain Star *can be found in the Woodstock Library Collection of the Historical Society of Woodstock archives. No dates are provided with the articles.*

Chapter 14

The Many Legends of Big Indian

During the rides I used to take with my grandfather, there was always one town we would pass that intrigued me: Big Indian. In short, "what's in a name?"

As can actually happen in life, some things really are simple. In the case of my childhood question, such was the case. The town of Big Indian was, indeed, named after a big Indian. There, however, the simplicity ends. As one pursues the story of this "big Indian," the researcher quickly learns that there are at least four variations on the tale—four differing accounts of how and why the name Big Indian ended up as the name of a small town in the Catskill Mountains.

The first tale, thought devoid of connection to any women, can be found in Wallace Bruce's 1907 work *The Hudson*. In this version, "a large noble red man" apparently endeared himself to white settlers in Esopus Valley by swearing off scalping and other bad habits. Instead, this seven-foot native turned his attention to farming and other pursuits thought more civilized by the white settlers around him. Unfortunately, life did not reward his decision, as the Indian was attacked and killed by a pack of wolves. Buried nearby, a big Indian was carved from a tree as "his monument."

In his work *The Catskills: From Wilderness to Woodstock*, historian Alf Evers relates a quite different version as told by the Reverend J.R. Hoag

to the *Recorder and Democrat* newspaper of Catskill in 1862. In this telling, the large Indian was of a far different temperament than the one offered in Bruce's account. During the time of Revolution, according to Hoag, a giant Indian would enter nearby settlements and "kill and burn" unsuspecting inhabitants. During one such incident, the Indian is said to have even killed a young girl. Vowing revenge, one settler set out to end this one-man reign of terror, announcing that he would not "return until himself or the Big Indian was slain." Finding the Indian seated by a campfire one night, the settler shot, killed and then buried the settlers' nemesis on the site that has since been known as Big Indian.

In a somewhat similar telling of the tale, Alphonso Clearwater, in his 1907 *History of Ulster County*, reproduces an account offered by Henry Griffeth. In this version, the large Indian continues to terrorize area settlements. Vowing to seek revenge, local settlers seek out the Indian and, after finding him "where Birch Creek empties into the Esopus," kill their antagonist. Not content with his death, legend has it that the Indian was then stood up "against the body of a large pine tree and, in a rude way, cut his profile upon it." Though the tree would eventually be cut down, the area remained known as Big Indian.

While each of the tales above is intriguing, each is still without a woman at the heart of the story. Enter yet another telling of the legend, as found in Charles M. Skinner's work *Myths and Legends of our Own Land* (1896). In this version, which some believe, as Evers indicates, may have been the work of PR men representing the Ulster and Delaware Railroad, our Big Indian has a name—Winnisook. He is still seven feet tall but neither engages in agriculture or attacks innocent villagers. Rather, he falls in love. The story takes on added intrigue (and added PR value if you are trying to attract visitors to the Catskills) when we learn that the object of Winnisook's love is a white woman by the name of Gertrude Molyneaux. Though Molyneaux was not shy about returning the big Indian's affections, her family would have no part of it when Winnisook asked for her hand in marriage. Instead, poor Gertrude was pushed into a loveless marriage with someone of "her own kind," a man by the name of Joseph Bundy. Marriage to Bundy convinced Gertrude that life would be better with Winnisook and, in pursuit of her own happiness, "eloped" with the big Indian. It would be quite some time before the couple would be

Winnisook (aka Big Indian), as he is remembered today. *Photo by the author.*

seen again, and were it not for a mistake by Winnisook, the couple might have lived "happily ever after." However, in an attempt to steal cattle, Winnisook was recognized by a farmer, and the chase to track down the big Indian and recover his white wife was on.

Leading the chase was one Joseph Bundy. According to the account in Skinner's text, upon eventually finding Winnisook, Bundy was said to have proclaimed, "I think the best way to civilize the yellow serpent is to let daylight into his heart." With that, Bundy fired and shot Winnisook. It is said that the Indian, not only big in size but also big in heart as well, managed to stagger "into the hollow of a pine tree, where the farmers lost sight of him. There, however, he was found by Gertrude, bolt upright, yet dead." Defiant in her feelings toward her own, to those who would do this to Winnisook, it is told that Gertrude lived the remainder of her days with her "dusky children" near the place where Winnisook died—the place now known as Big Indian.

As I would eventually drive along the Route 28 corridor with my own children, it was the tale of Winnisook and Gertrude I would tell them. Whatever its origins, it seemed more worthy than the others as one looked out at the surrounding mountains, heading west, past a sign marked Big Indian. Some tales you just want to believe. Some images you want to retain. That of a defiant Gertrude is one.

Chapter 15
Beautiful Spring
The Legend of Utsayantha

She plunged beneath the wave, and sank to drown;
The waters closed above; the pine trees sighed
The pale moon looked in silent pity down.
—*Eugene Bouton,* Utsayantha's Legend

I have saved the legend of the Indian maiden Utsayantha for the end of this text. In many ways, it is symbolic of much of what the preceding pages have attempted to offer. For, in the story of Utsayantha, one finds that love and self-worth are often in conflict—or are directed—by a world where free will has a decidedly male provenance.

The legend of Utsayantha—the name means "beautiful spring"—is many parts mountain lore and public relations hype. Not unlike that of Winnisook, there are variations in the story as one tracks the record over time. That being said, it is not a story we should reject simply because it is difficult to base on fact. Rather, in its tragic consequences, and even in its most tainted presentation as a means of attracting tourists, Utsayantha's story tells us of another time and another place, a time and a place that has a right to an equal share of Catskill Mountain history.

The story is recognizable in any age, from the pages of Shakespeare to today's popular culture. It is the story of mismatched love—a "mixed

marriage," if you will—and the tragic consequences that can come from such a union. Such was often the end result when "savage" linked romantically with "civilization," a popular storyline that also found its way into fictional literature during the nineteenth century. A similar tragedy can be found, for example, in "Malaeska, the Indian Wife of the White Hunter," the fictional tale of a Mohican maiden living near Catskill, which appeared in the *Ladies Companion* in 1839. In this variation, the author, Ann Sophia Stevens, weaves a story of hidden identity as an Indian woman, who bore a white man's child, is sent to New York to live with his white family following his death. There the child is raised as white, as the mother must abandon her "Indian claim" to him. Eventually, back in Catskill, the now grown child is told his true identity just prior to his own marriage. Unable to cope with the truth, he, not unlike Utsayantha, leaps to his death. Malaeska's own death would follow. At its heart, the legend of Utsayantha, and others like it, represent a tale of lost love, power, prejudice and tragedy. In a world where both white and Indian women found themselves at the point of exclusion from what mattered, selfless acts—in fiction or reality—were often required to right perceived wrongs.

Near the village of Stamford, New York, lies Mount Utsayantha. From its peak, the visitor is offered one of the more beautiful views in the Catskills. Stamford, once knows as the "Queen of the Catskills," made its mark during the latter part of the nineteenth century as host to summer tourists who would flock to occupy its many boarding homes. At one point in the early twentieth century, it was estimated that more than five thousand visitors undertook the trek to the summit of Mount Utsayantha during one single season. The fact that a beautiful young Indian maiden might have plunged to her death in the waters below its slopes certainly didn't hurt the attraction.

The legend of Utsayantha appears to have been first penned as a poem by Eugene Bouton and is found in the June 1874 edition of the *Yale Literary Magazine*. Drawing from and combining other myths, facts and folklore from the history of the Catskills, Arnold H. Bellows crafted a full-length poem in 1945, titled "The Legend of Utsayantha" in hopes of awakening "an interest in local history or legendary lore." Yet, even prior to the works of Bouton and Bellows, interest

and awareness of Utsayantha's place in Catskill Mountain lore was underscored when, in 1862, it was believed her grave was found atop Mount Utsayantha. While the authenticity of the grave has long been doubted, a marker noting the site of "Princess Ut-say-an-tha's Grave" was erected in 1936.

Utsayantha was the daughter of a powerful and proud Indian chief, Ubiwachah. Displeasure raged in the chief when he learned of his daughter's love for a white man. Between Utsayantha and her lover, a child had been born. Anger seized the father even more, and death was brought to the white man.

How he died, however, is the subject of two different interpretations. The first, as found in the poems of Bouton and Bellows, has the white man slain by an arrow from Ubiwachah's bow.

> *An arrow sung and in Death's arms he slept.*
> —Bouton

> *In his heart a burning hatred.*
> *Such the aim of Ubiwachah,*
> *That his deadly dart unerring*
> *Pierced the bosom of the white man,*
> *Who arose and reeled, and falling,*
> *Lifeless lay beside his dwelling.*
> —Bellows

In another version of the demise of Utsayantha's lover, the death he suffers is far more graphic and brutal, as Ubiwachah buries a tomahawk deep inside his skull. When and why the death of the white hunter morphed into its more shocking version is unclear. Whether it simply made a better "story" for the purpose of attracting visitors to the area is not known. Certainly, though, it was not a part of the original poem penned by Bouton or later expanded upon by Bellows.

Though the man who had wooed his daughter away lay dead, Ubiwachah's revenge was not complete. Taking the child from his mother's arms, Ubiwachah rowed a canoe to the middle of the lake as Utsayantha looked on from shore:

She saw it pause half-way across the lake;
She saw a hand upraise her infant o'er
The wave; she heard a larger ripple break;
She marked the spot, nor elsewhere looked she more.
—Bouton

The child of their love was dead. The love with whom the child was made also lay dead, both victims, as Bellows writes, of her father's "vengeance." With little left, she quietly rowed herself to the spot where her child had been drowned. There, with arms raised above her, she

Fell upon the gleaming water,
Utsayantha plunged beneath it,
And her spirit fled from sorrow,
To the realms of the immortal.
—Bellows

Interestingly, the legend of Utsayantha, according to Bouton, ends there. However, as anyone familiar with the tale knows, and as Bellows goes on to chronicle, the story concludes with a final act, as, the once-proud Ubiwachah, bereft in grief, bore his daughter's body up the mountain that now carries her name and buried her there, where, supposedly, she lies till this day.

Perhaps the legend of Utsayantha is just a story, a tale based on a slim bit of fact. Most myths and legends are. Yet Utsayantha, in its telling, is accessible to us. As a result, the sympathy we have for her is not beyond our own human comprehension, no matter how much the demands of commerce have attempted to co-opt her story over time. She loves and is loved; she is a mother; she is mortal and, in a world "civilized" or "savage," real or imagined, her existence was not her own. Buffeted by vengeance, revenge, intolerance and hate—all decidedly "unfemale" traits in myth and legend—she seeks from within the strength to find her own freedom, her own liberation. As a result, her life and death offers a reflection no less dim than that which reality offered within the context of time and place.

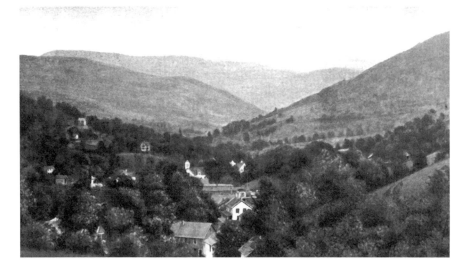

View of the Catskills from Pine Hill, New York. *Author's collection.*

Author's note: "Malaeska, the Indian Wife of the White Hunter," by Ann Sophia Stevens, in addition to appearing in Ladies Companion, *appeared in book form in 1860 as one of the first "dime store" novels and enjoyed great commercial success. Released by the firm of Beadle and Adams, it is said to have sold over 300,000 copies in its first year. Copies can still be found today.* The Legend of Utsayantha *by Arnold H. Bellows, illustrated by Lamont A. Warner and published by the* Catskill Mountain News *(1945), can also be found in various libraries and online. Similarly, Eugene Bouton's original poem, "Utsayantha's Legend" can be found online in the May 1874 edition of the* Yale Literary Magazine *39.*

About the Author

Richard Heppner has served as town historian for Woodstock, New York, for the last ten years. He also serves on the board of directors for the Historical Society of Woodstock and the Woodstock Memorial Society. Over the years, he has authored and edited numerous essays and texts on Woodstock's unique history. He is a graduate of the State University of New York at Albany with a degree in political science and history. He also holds a master's degree in media studies from the New School for Social Research. Since 1988, he has been employed by Orange County Community College, where he has served as a faculty member, department chair, associate vice-president for liberal arts and currently as vice-president for academic affairs. Residing in Woodstock, New York, with his wife, Deborah and two children, Eliza and Jonathan, his previous work for The History Press includes *Remembering Woodstock* (2007).

Visit us at
www.historypress.net